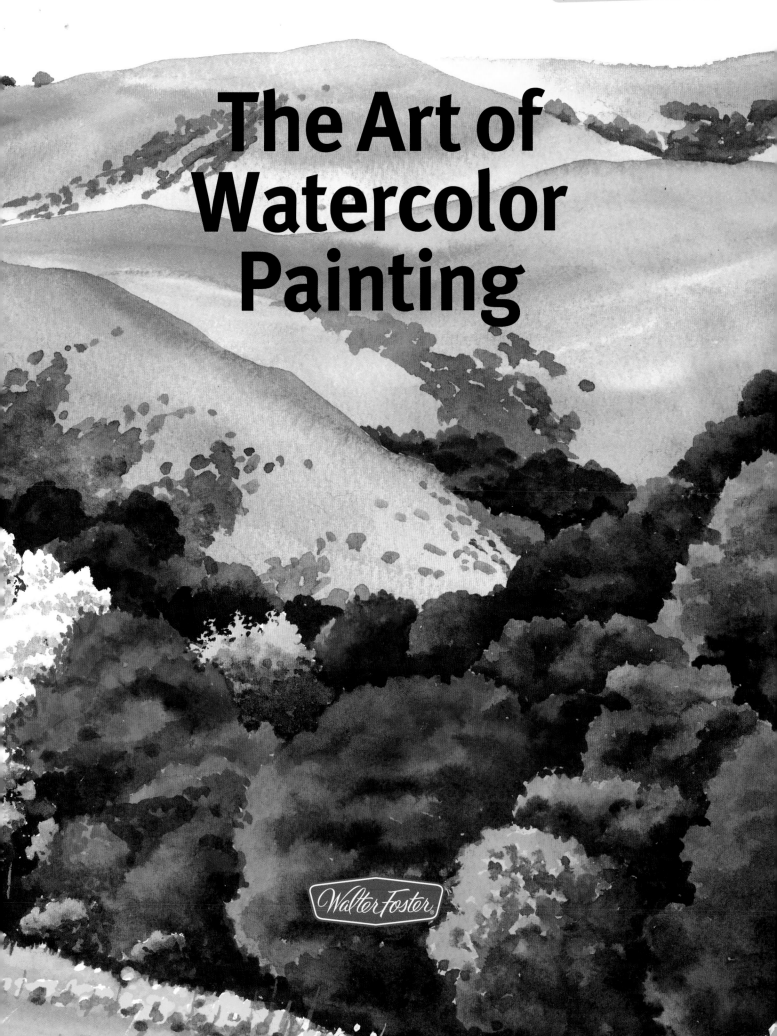

# The Art of Watercolor Painting

Authors: Thomas Needham, Ronald Pratt, Helen Tse, Deb Watson, Nancy Wylie
Publisher: Rebecca J. Razo
Art Director: Shelley Baugh
Project Editor: Stephanie Meissner
Associate Editor: Jennifer Gaudet
Assistant Editor: Janessa Osle
Production Artists: Debbie Aiken, Amanda Tannen
Production Manager: Nicole Szawlowski
Production Coordinator: Lawrence Marquez
Production Assistant: Jessi Dyer

www.walterfoster.com
Walter Foster Publishing, Inc.
3 Wrigley, Suite A
Irvine, CA 92618

Printed in China.
10 9 8 7 6 5 4 3 2 1
18202

# The Art of Watercolor Painting

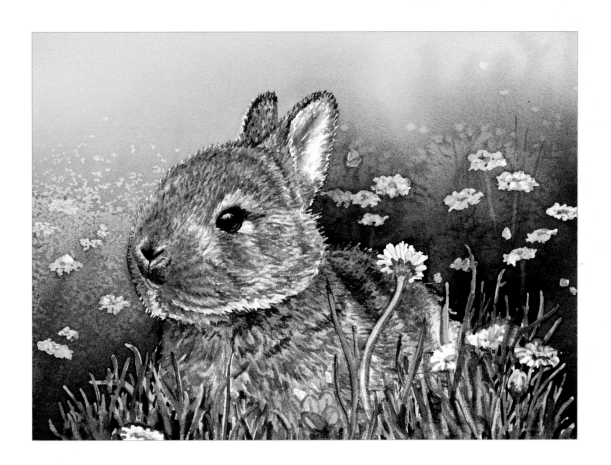

# Contents

# Introduction

**WATERCOLOR IS A VERSATILE AND LUMINOUS MEDIUM.** The airy and atmospheric quality of watercolor paints truly sets them apart from other mediums. Made of pigment suspended in a binder of gum arabic, this fluid medium requires a bit of practice to master. And even after you have learned to control the moisture, its best to stay open for spontaneity—you can never fully control watercolor paint, but that is what makes it so exciting to paint with!

Devote yourself to learning and understanding how to work with watercolor, and you will quickly understand why it is praised for its ability to quickly capture an essence, suggesting form and color with just a few brushstrokes.

Each chapter in this book guides you through step-by-step lessons designed to help you master the art of watercolor painting. From concepts to techniques to subject-specific tips, follow along as five talented watercolor artists offer expert insight and instruction to both educate and inspire.

As you begin your artistic journey with watercolor, remember to relax and enjoy the painting process. Let your creative muse out! It is one of the greatest joys in life to unleash your inner creativity and watch a beautiful painting emerge before your eyes.

# Tools & Materials

## Paints

Watercolor paints are available in cakes, pans, and tubes. Many artists prefer tube paints, because they are fresher and the colors are brighter. It is best to use good quality paint, but if you are just starting out it's okay to use less expensive student-grade paint and upgrade to professional grade later. You don't need to have a huge palette of color. You'll find that each of the artists in this book works with their own palette of colors, listed at the beginning of each project. You may find you prefer to work with different paints, so don't be afraid to experiment. You'll also want white gouache for touch-ups and highlights.

## Brushes

There are many kinds of paintbrushes available, but they can be narrowed down to two types: synthetic and natural hair. Synthetic brushes are usually less expensive than natural ones, but they don't retain water as effectively. Synthetic brushes are great for working with masking fluid. For the projects in this book, you'll want a variety of flat and round brushes in varying sizes, a hake brush, and a rigger brush. Make sure you have one small round detail brush and several synthetic brushes for masking.

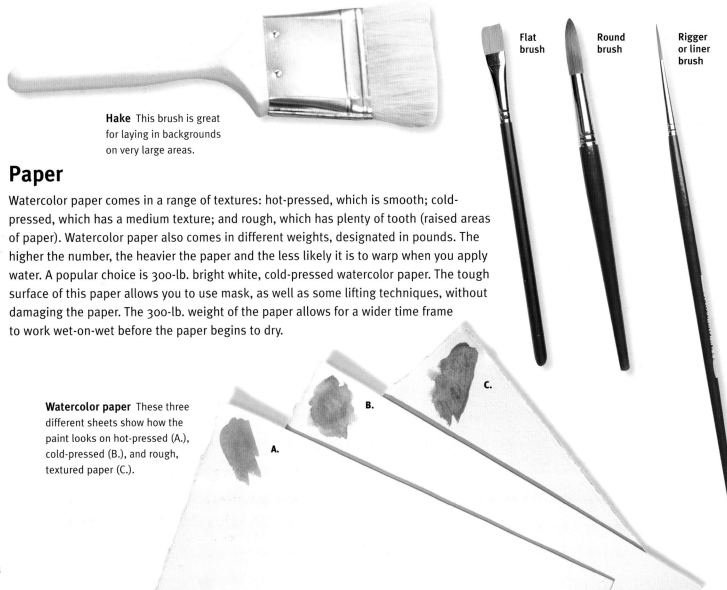

**Hake** This brush is great for laying in backgrounds on very large areas.

**Flat brush**

**Round brush**

**Rigger or liner brush**

## Paper

Watercolor paper comes in a range of textures: hot-pressed, which is smooth; cold-pressed, which has a medium texture; and rough, which has plenty of tooth (raised areas of paper). Watercolor paper also comes in different weights, designated in pounds. The higher the number, the heavier the paper and the less likely it is to warp when you apply water. A popular choice is 300-lb. bright white, cold-pressed watercolor paper. The tough surface of this paper allows you to use mask, as well as some lifting techniques, without damaging the paper. The 300-lb. weight of the paper allows for a wider time frame to work wet-on-wet before the paper begins to dry.

**Watercolor paper** These three different sheets show how the paint looks on hot-pressed (A.), cold-pressed (B.), and rough, textured paper (C.).

**A.**

**B.**

**C.**

## Palette

Palettes come in different materials—plastic, glass, china, wood, or metal—and in various shapes. Plastic is lightweight and less expensive than other materials. All these palettes will clean up easily with soap and water. No matter what style you choose, try to find one with a large, flat area for mixing and creating washes and plenty of wells for holding all your colors.

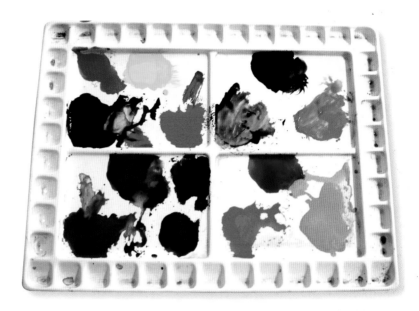

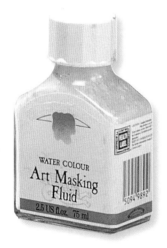

## Masking Fluid

Masking fluid, or liquid frisket, is a latex-based substance that can be applied over areas you want to keep white. When dry, the mask repels paint, so you can paint over it without covering the white support underneath. When the paint is dry, gently rub off the mask with masking fluid pickup or an old rag. You can also apply masking fluid over color that is already dry to protect areas from subsequent layers of color.

## Sea Sponges & Toothbrush

Natural sea sponges are perfect for applying foliage texture such as blossoms or leaves. You can use sea sponges to apply masking fluid instead of a brush. Just dip the sponge in your paint or masking fluid and dab onto the watercolor paper. Have an old toothbrush on hand for splattering paint to create natural textures.

## Additional Materials

A few other items you may want to have on hand are masking tape, tissue, a craft knife, a palette knife, and cotton swabs.

# Watercolor Techniques

Here are some ways you can apply and manipulate watercolor paint.

**Flat Wash** For this basic technique, cover your paper with horizontal bands of even color, starting at the top and working your way down.

**Graduated Wash** Load your brush and apply overlapping strokes, adding water with each consecutive stroke. The color will gradually thin out as you continue.

**Soft and Hard Lines** For a hard line, paint a dry stroke on dry paper. Any line can be softened by blending the edge with clear water before it dries. This is useful for areas where detail is not needed.

**Stippling** Stippling means to apply the paint with dots or light touches of the brush. This adds texture and interest while still allowing the underpainting to show through.

**Negative Painting** Negative painting involves painting around the desired shape rather than painting the shape itself. Instead of painting a leaf, paint the area around the leaf.

**Masking Fluid** Masking fluid is liquid latex that allows you to protect areas that you want to remain white in an otherwise dark picture. Paint the area you want with the masking and let it dry. To remove, rub it off with your fingers or a rag. Since it can be difficult to remove from brushes, use an old brush or a rubber-tipped brush for thin lines.

## Charging In Color

This technique involves adding pure, intense color to a more diluted wash that has just been applied. The moisture in the wash will grab the new color and pull it in, creating irregular edges and shapes of blended color. This is one of the most fun and exciting techniques to watch—anything can happen!

**Creating a Charged-in Tree Color** First apply a wash of phthalo blue (left); then load your brush with pure burnt sienna and apply it to the bottom of the swatch (center). Follow up with pure new gamboge on the opposite side, and watch the pigments react on the paper (right). Remember that pigments interact differently, so test this out using several color combinations.

# Wet-on-Dry

This method involves applying different washes of color on dry watercolor paper and allowing the colors to intermingle, creating interesting edges and blends.

▶ **Mixing in the Palette vs. Mixing Wet-on-Dry** To experience the difference between mixing in the palette and mixing on the paper, create two purple shadow samples. Mix ultramarine blue and alizarin crimson in your palette until you get a rich purple; then paint a swatch on dry watercolor paper (near right). Next paint a swatch of ultramarine blue on dry watercolor paper. While this is still wet, add alizarin crimson to the lower part of the blue wash, and watch the colors connect and blend (far right). Compare the two swatches. The second one (far right) is more exciting. It uses the same paints but has the added energy of the colors mixing and moving on the paper. Use this mix to create dynamic shadows.

▶ **Mixing a Tree Color** Next create a tree color. First mix green in your palette using phthalo blue and new gamboge, and paint a swatch on your paper (near right). Now create a second swatch using a wash of phthalo blue; then quickly add burnt sienna to the bottom of this swatch. While this is still wet, add new gamboge to the top of the swatch. Watch these three colors combine to make a beautiful tree color that is full of depth (far right).

# Variegated Wash

A variegated wash differs from the wet-on-dry technique in that wet washes of color are applied to wet paper instead of dry paper. The results are similar, but using wet paper creates a smoother blend of color. Using clear water, stroke over the area you want to paint and let it begin to dry. When it is just damp, add washes of color and watch them mix, tilting your paper slightly to encourage the process.

▶ **Applying a Variegated Wash** After applying clear water to your paper, stroke on a wash of ultramarine blue (near right). Immediately add some alizarin crimson to the wash (center right), and then tilt to blend the colors further (far right). Compare this with your wet-on-dry purple shadow to see the subtle differences caused by the initial wash of water on the paper.

# Wet-into-Wet

This technique is like the variegated wash, but the paper must be thoroughly soaked with water before you apply any color. The saturated paper allows the color to spread quickly, easily, and softly across the paper. The delicate, feathery blends created by this technique are perfect for painting skies. Begin by generously stroking clear water over the area you want to paint, and wait for it to soak in. When the surface takes on a matte sheen, apply another layer of water. When the paper again takes on a matte sheen, apply washes of color and watch the colors spread.

▶ **Painting Skies Wet-into-Wet** Loosely wet the area you want to paint. After the water soaks in, follow up with another layer of water and wait again for the matte sheen. Then apply ultramarine blue to your paper, both to the wet and dry areas. Now add a different blue, such as cobalt or cerulean, and leave some paper areas white (near right). Now add some raw sienna (center right) and a touch of alizarin crimson (far right). The wet areas of the paper will yield smooth, blended, light washes, while the dry areas will allow for a darker, hard-edged expression of paint.

# Glazing

Glazing is a traditional watercolor technique that involves two or more washes of color applied in layers to create a luminous, atmospheric effect. Glazing unifies the painting by providing an overall underpainting (or background wash) of consistent color.

▶ **Creating a Glaze** To create a glazed wash, paint a layer of ultramarine blue on your paper (near right). Your paper can either be wet or dry. After this wash dries, apply a wash of alizarin crimson over it (far right). The subtly mottled purple that results is made up of individual glazes of transparent color.

# Color Theory

## The Color Wheel

The color wheel (at right) shows how color pigments relate to one other. Red, yellow, and blue are *primary* colors and cannot be created by mixing any other colors. *Secondary* colors are mixed from two primary colors and include orange, green, and purple. Colors directly across from each other (e.g., blue and orange) are complementary colors. *Tertiary* colors are made by mixing a primary color with a secondary color. For example, mixing red (a primary) with purple (a secondary) makes red-violet. If you mix the three primaries together in varying proportions, you'll get a range of neutrals (browns, grays, and even blacks).

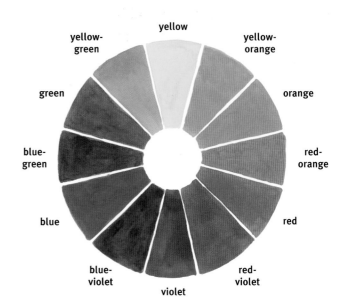

## Color Schemes

Color schemes are combinations of colors that create various effects in a painting—from unity to dynamic contrasts. Each color scheme garners a different response from the viewer, so you'll want to think about your subject and the atmosphere you want to convey. Familiarize yourself with the common color schemes below.

**Monochromatic** Monochromatic paintings are made up of variations of one color, such as the purple painting at left. A pencil drawing or a black-and-white photograph, however, are called "achromatic."

**Primary** A primary color scheme uses the three primary colors: yellow, blue, and red.

**Analogous** This color scheme uses a series of three to five colors next to one another on the color wheel. In this example the artist used yellow-green, green, and blue-green.

**Complementary** Placed next to each other in a painting, complementary colors make each other appear brighter, which makes for a vibrant color scheme.

**Split Complementary** This uses one main color and the colors adjacent to its complementary color. In this example the artist used yellow, red-violet, and blue-violet.

**Triadic** Uses three colors that are equally distant from one another on the color wheel. In this example the artist used violet, green, and orange, resulting in a strong contrast.

# Stretching Your Own Paper

To stretch watercolor paper the old-fashioned way, you'll need a piece of plywood, a light duty staple gun, and a pair of beveled pliers. You may also want to use a lamp (not fluorescent) or hair dryer to speed the drying process.

**1.** Begin by soaking the paper in tepid water in a large tray for about 10 minutes. To remove the paper, grab it by one corner and hold it up to let the excess water drain.

**2.** Place the paper on the plywood and blot with paper towels. Gently pull the paper diagonally across the long sides and place two staples near the center on the outer edge of each short side.

**3.** Grab one corner and pull diagonally. Hold the paper in place and put one staple on each side of the corner. Repeat for the other three corners.

**4.** Continue stapling along the outer edges until you've placed about eight staples per 14" side.

**5.** Gently blot more water out of the paper and place somewhere to dry for about 24 hours before painting. Once your finished painting is dry, gently remove the staples with your pliers. Trim off the stapled edges with a paper cutter.

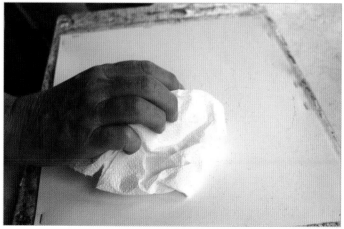

# CHAPTER 1

## Beginning Watercolor

### with Nancy Wylie

Watercolor is a unique and challenging art form—much more interesting and complicated than the row of rainbow boxes you used as a grade school student! Watercolors can capture a sunset, a tree line, or a mountain range in a way no other medium can. In this chapter, you'll learn how to paint skies, trees, bushes, grasses, flowers, snow, and even a barn. Each of the six lessons in this chapter will take you through different watercolor techniques, including wet-into-wet, drybrush, texturizing, and masking. Watercolor is so versatile, and the lessons in this chapter will teach you both how to use these techniques and when to use them to achieve the effect you want.

# Exploring Color

There is nothing quite like the colors of spring. In this painting I exaggerated the flowers to add a little more depth and brightness. This is a good exercise in taking a somewhat dull reference photograph and creating a painting with brighter colors. Using a reference that has good composition but dull colors means you can change a great deal with your imagination. You don't have to paint exactly what is in the photo!

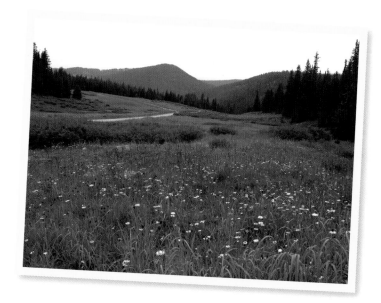

**1.** First I make a thumbnail sketch to determine my values and composition.

*Palette*

burnt sienna, hansa yellow, lemon yellow, raw sienna, sap green, thalo blue, ultramarine blue, yellow ochre

**2.** I make a line drawing on my paper. Then I mask in all the different flowers, adding a few extras where it seems natural. I also paint a few random leaf or stem strokes to help break up the color and create the illusion of foreground turning into the background. Finally I add a little bit of masking to the road in the distance.

**Artist's Tip**

I use a little burnt sienna in blue skies because skies always have a tiny bit of warmth to them. Pure blue out of the tube always looks fake or garish. Skies are generally a darker cool ultramarine blue at the top, changing to a thalo blue, and then to a warmer and lighter cerulean blue toward the bottom.

**3.** I wet the sky area with clear water first. Then I use a mixture of ultramarine blue, a tiny bit of thalo blue, and a touch of burnt sienna to make a fairly flat wash for the sky, keeping it slightly lighter near the horizon and darker near the top. Next I work on the hills from light to dark, using varying mixtures of ultramarine blue, burnt sienna, sap green, and a touch of thalo blue. On the foreground hill I use a little more sap green and a touch of raw sienna.

**4.** I mix several puddles of colors before starting to paint. I paint the lightest value with a mix of lemon yellow and ultramarine blue, adding in bits of yellow ochre while it is still wet. I slowly change colors, mixing in darker greens towards the foreground grasses and flower stems, and using different mixtures of ultramarine blue, burnt sienna, thalo green, sap green, and some hansa yellow. Next I paint the bushes and flat green areas in the distance. I then work in the foreground around the masked flowers, using a very random back-and-forth motion to create the grasses and stems. Once dry, I go back in over all the grass strokes with a light yellow green to fill in all the little white areas that are showing through. I then take a damp brush and soften the edges between the flowers and the transition to the distant meadow.

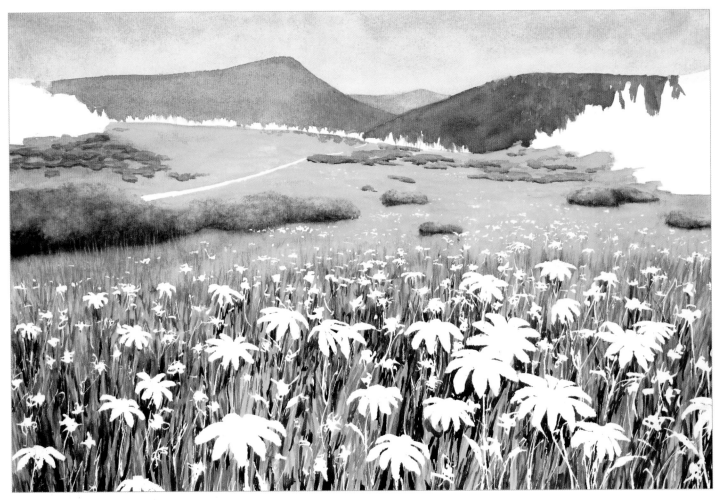

**5.** I remove the masking with a rubber remover. All the rough edges will be cleaned up when I paint the flowers and stems.

*Artist's Tip*

Because the foreground flowers are imaginary and I am not painting an exact likeness to a photo or to real life, I place small pieces of yellow construction paper in the centers of the daisies on the white unmasked areas to make sure I saved a balance of white to yellow. This way I can see where the white daisies are and where I plan to paint the yellow flowers. Using the construction paper as a placeholder allows me to move things around before committing them to paint.

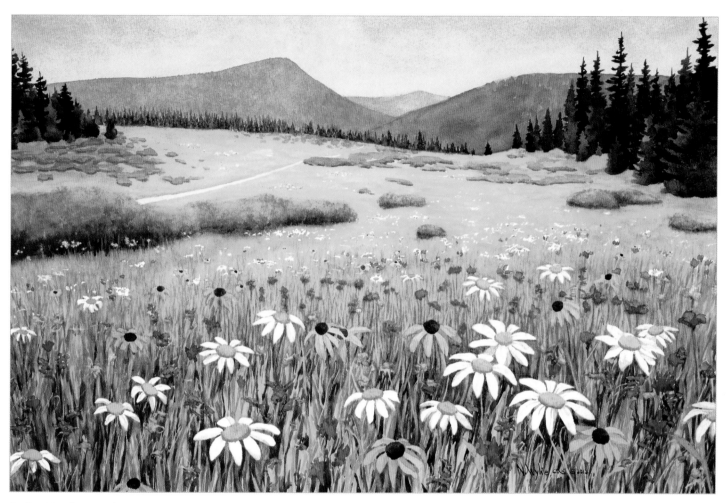

*Spring Meadow,* 13 ½" × 21"

**6.** I paint each flower differently because in nature each flower is unique. Next I paint the other flowers as an abstract suggestion of red, pink, and purple wildflowers. I then paint the trees in the distance. I put a piece of masking tape along the hill edge to keep the dark tree paint from going down into the hill. I paint every other tree so that after one tree dries I can go back and paint between the trees, light and dark, varying the color. I do the same with the bigger trees in the left and right side middle ground. After painting the dark pines I take my worn-out brush and add more drybrush texture to the bushes in front. I then add some glazes of color to the meadow grasses in the distance. I also take a very small wet brush and clean up any edges.

# Developing Landscapes

There is something warm and inviting about a farmer's field in the summertime. I love the colors in this photograph: warm greens of growing crops, a golden meadow, white wildflowers, and a red barn in the distance. I decided to replace the mountainous background with white, puffy clouds in a blue sky, for visual interest.

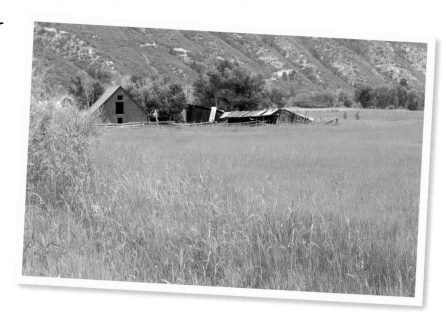

**1.** I make my value sketch first.

## Palette

aureolin yellow, burnt sienna, cadmium yellow, cerulean blue, permanent green light, perylene red, quinacridone magenta, sap green, thalo green, ultramarine blue, viridian, yellow ochre

**2.** I draw only the lines necessary for the key parts. Then I do a little masking so that when I paint the barn and sheds I can paint quickly without having to paint around a lot of the little details. I also mask a few of the highlights on the sheds. I use a hypodermic needle to mask some of the foreground grass, and I add in a few little flowers to make it more like summertime. (You can also use a rigger brush for this purpose.) This will allow the foreground to have a bit of detail and give the illusion of a lot of grasses and flowers without painting every blade or petal.

**3.** I blend different mixtures of blue paint, adding a combination of ultramarine blue and a touch of burnt sienna to cerulean blue. The sky needs to be painted quickly, so I blend enough on my palette so that I don't have to stop to mix more. I also mix some cloud colors, using a little bit of ultramarine blue, quinacridone magenta, and a touch of burnt sienna. I use clear water to wet the sky toward the trees and make sure not to get water on the barn. I then turn the painting upside down and work from the horizon to the higher part of the sky, randomly leaving dry cloud patches. I then take the cloud shadow colors and paint on the shadow side of the clouds, softening some places and leaving others hard-edged.

*Artist's Tip*

It's a good idea to do a thumbnail sketch first. This helps you ensure that the composition works, there is a focal point, and the values are correct. My thumbnail helped me determine the right value for the sky—a middle gray. It's better to make mistakes in a thumbnail sketch and correct them before spending time on the big painting.

**4.** For the field I use a mixture of permanent green light, yellow ochre, sap green, thalo green with bits of cadmium yellow, and a little mixture of perylene red and burnt sienna. Working from the background field with a cool green and golds, I change colors gradually, being careful to copy the colors and changes in the field in the photo. I also start using a flicking motion with my round brushes to create grasses, stems, and leaves of the few flowers that will be mixed into the front of the painting. I pay attention to where the masked grasses and flowers are so that they blend in with the right lights and darks around them. The bush is a combination of little quick strokes to re-create the texture of the leaves on the bush, with occasional sprays of water to create some soft edges.

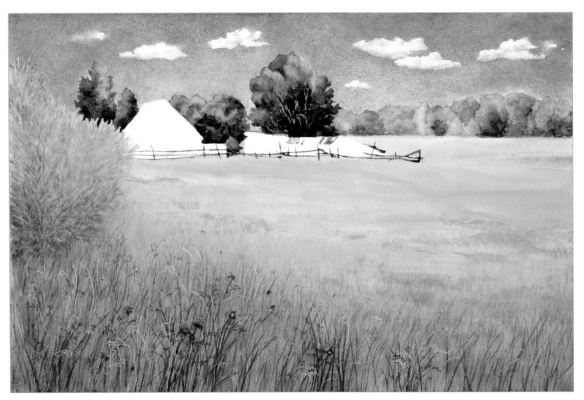

**5.** For the trees I use thalo green mixed with burnt sienna and varying degrees of aureolin yellow to create different shades. I also use a little ultramarine blue and yellow ochre for the lightest areas and a little ultramarine blue with burnt sienna and viridian for the darkest darks. I concentrate on keeping the farthest trees grayer and lighter and the closest trees darker and brighter because they're the darkest value in the painting. I paint the highlights first and then add the shadow colors, working on every other tree so that some places can dry with hard edges and others are soft and blended.

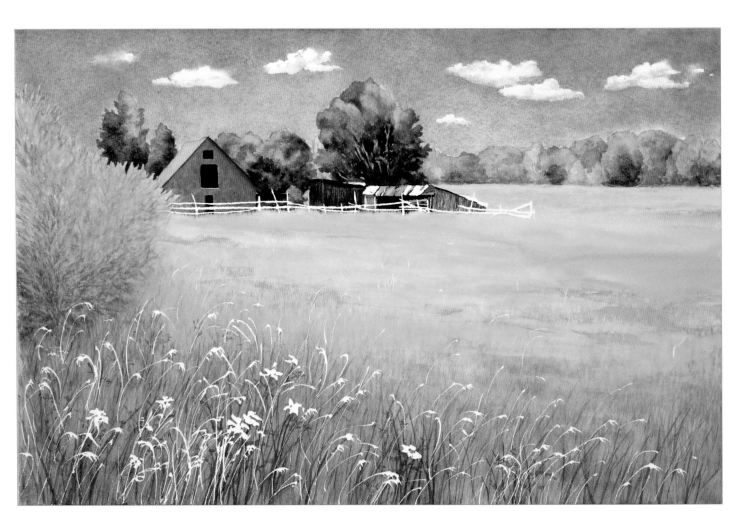

**6.** I use burnt sienna, ultramarine blue, and perylene red to paint the barn and sheds. After everything is completely dry, I remove the masking with the rubber mask remover. Now I'm ready to paint the flowers, grasses, and fence.

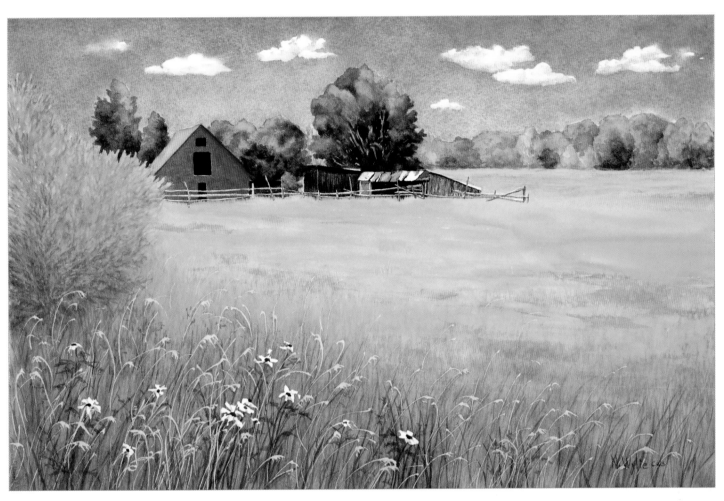

*Summer Barn,* 13 ½" × 21"

**7.** I use yellow ochre and cadmium yellow for the gold grasses and paint blue shadows and brown centers on the white flowers. I use ultramarine blue and burnt sienna to create different shades of brown and gray for the fence. I lighten and shape a little bit at the top of the big dark tree as it was too flat on the upper side. I add some more color to the front of the barn and put a glaze of yellow over the sunlit side of the barn roof to give it a little more warmth.

# Working with Perspective

Fall is one of my favorite seasons. I love to paint aspens because of the contrast between the beautiful blue sky and the golden leaves of the tree. I find the unique perspective of looking up into the aspen creates exciting shapes for me to work with.

## Palette

burnt sienna, cadmium orange, cadmium yellow deep, cadmium yellow medium, cerulean blue, gold ochre, hansa yellow medium, lemon yellow, permanent green light, raw sienna, ultragreen blue

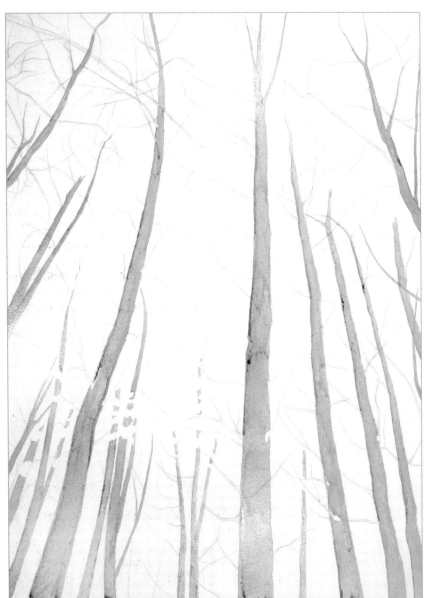

### Artist's Tip

Be sure to mask just slightly over the pencil line, especially on the sunlit side. The pencil line can be erased after the masking is removed, but not if it's under a layer of paint.

**1.** After I have stretched, stapled, and taped the paper, I make my line drawing. I make everything as accurate as possible because the drawing will define the perspective. Once the lines are drawn I can proceed to masking the tree trunks so I can paint the leaves quickly without covering up the trunks or losing the white highlighted sunlit edges—the most critical parts need to be saved. I mask only the main trunks of the trees. I also pay special attention to where the leaves overlap some tree trunks, leaving those areas unmasked so that when I paint the leaves they will look like they're in front of the trees.

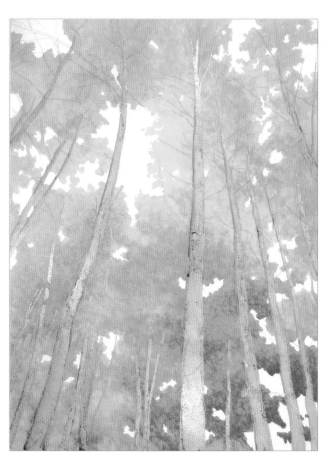

**2.** I start working on the trees in the upper right quadrant, beginning with the lightest yellows and then moving into light yellow greens. I then change to a mixture of permanent green light with yellow ochre or burnt sienna to make a rusty gold. I use a large round brush to get the majority of the shapes and colors in, changing color as I work. Then I use an old wet brush and a dabbing motion to soften the edges, leaving holes for the sky. Poking straight down works great for doing trees, bushes, and shrubs, as it softens edges and shows texture without painting every single leaf. This technique can damage the brush, so use one you don't need anymore.

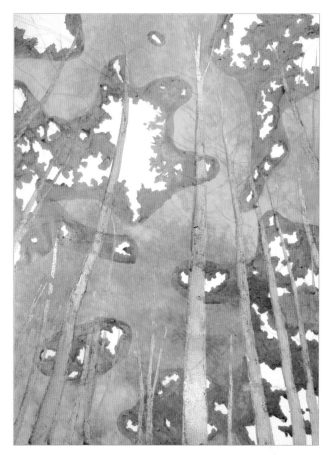

▲ **3.** I decide to mask around all the sky holes to prevent the sky from mixing with the yellow Aspen leaves and so that I don't end up with green edges. I mask the edges of the leaves with the hypodermic needle and then use a masking brush to fill in the bigger areas to protect the yellow leaves from the blue paint.

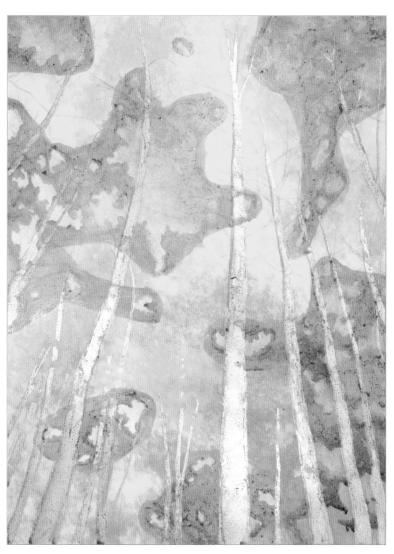

**4.** Using a 3/4" flat synthetic brush, I paint the sky with a mixture of ultramarine blue and cerulean blue with a touch of burnt sienna. Because the sky holes are small, I paint wet-on-dry, in a crisscross motion, blending quickly. Small sky holes are generally darker than big areas of the sky. Once all is covered I work back into some spots and crosshatch with my brush with water and paint to darken, lighten, or even out areas that aren't perfectly smooth.

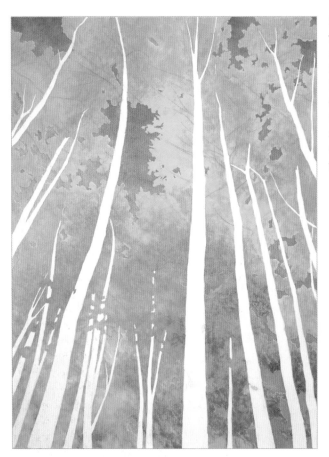

**5.** Next I remove all the masking with a rubber remover and clean up all the edges. In areas where the blue sky paint went over the masking and needs to be lifted off the leaves of the trees, I take a small, clean damp brush and rub a thin line along any edge that needs it. When the paper is completely dry, I use a white plastic eraser to erase all the pencil lines, especially on the sunlit side of the tree trunks where the paper will be left pure white. Some pencil marks under the leaves show, but I need to see those to paint the dark black branches later on. Once pencil lines are covered with paint I cannot erase them, so I pay attention to which lines I want to see.

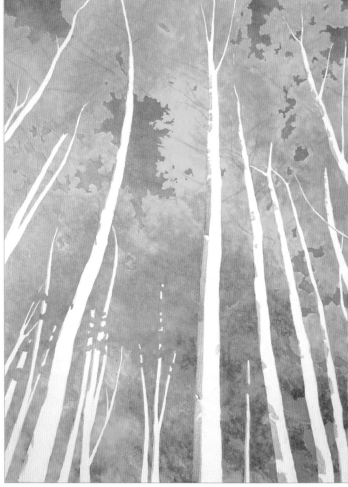

▲ **6.** Now I mask the highlights of the tree trunks. I often use a hypodermic needle to do fine line edges, but you can also use a rigger brush. I pay attention to where the highlights are in the photograph to make sure that the masking is in the right place.

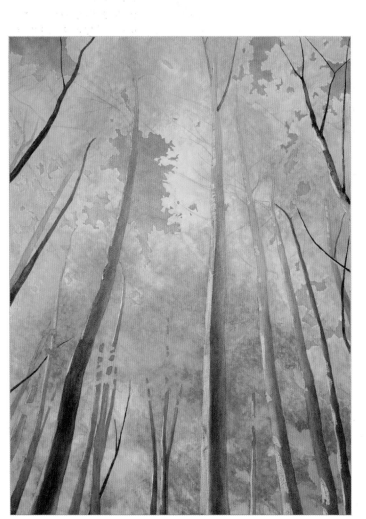

**7.** After masking the highlights, I'm ready to paint the tree trunks. I use an assortment of brush sizes depending on the tree size. I use different mixtures of everything from ultramarine blue to burnt sienna to cadmium yellow deep, yellow ochre, and a little touch of permanent green light, depending on what color is needed on what part of each tree. I work on the smallest trees first to test the colors to get my values right. I work from top to bottom on each tree, and then turn my painting sideways and work on the bigger trees from the tops to the trunk bottoms.

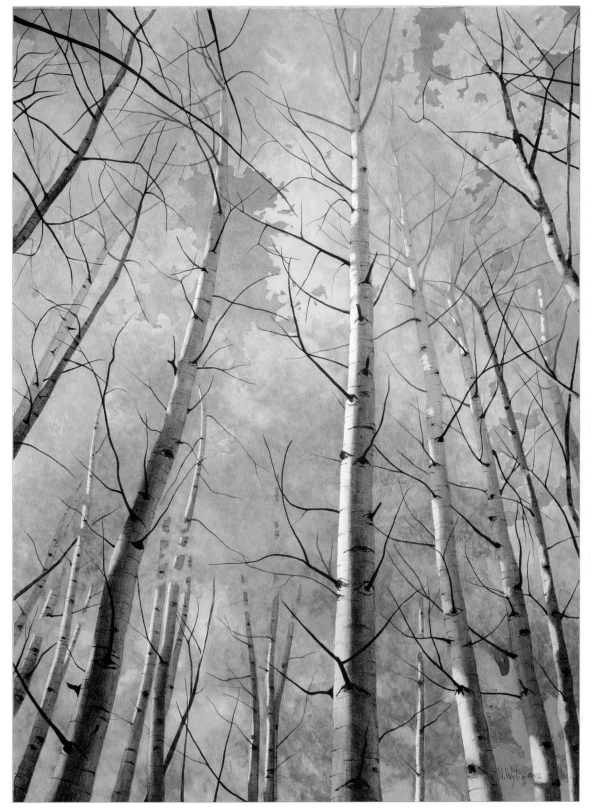

**8.** I remove the masking on the tree trunks and clean up the rough edges with a damp brush. Softening the edge to the right makes the tree trunks look round because it builds a ridge of paint that becomes the darkest part of the trunk in the middle, and then fades to the lighter value on the left side. With a small round brush, I start working tree by tree. The branches that are in the highest parts of the trees are very light, becoming darker and blacker as they near the earth and the foreground of the painting. With a rigger brush, I add a few extra branches. Next I paint the details, such as where the branch comes out of the trunk and the small ridges and lines in the aspen. Finally I lighten the upper left tree by putting a layer of water over it, laying a tissue on it, and lifting it off. After the paper is dry I paint a glaze of brown over it to warm it up.

*Autumn Glory,* 28 ½" × 21"

*Artist's Tip*

Notice that the colors in the trees are light to dark from top to bottom, as well as around the trunk. As you paint each tree from top to bottom, try to paint the shifts in color one continual step at a time. If your layer is too light or the wrong color, completely dry it with a blow dryer and add another layer.

# Rendering Snow

My goal in this painting is to show how painted snow demonstrates the illusion of light and shadow in the winter. Snow is not simply white; it is actually full of color. Without the hues of different blues, purples, pinks, and grays, snow will look flat. When painting a backlit scene, there is also the issue of creating the illusion of light, which is particularly beautiful in this scene.

## Palette

burnt sienna, cerulean blue,
permanent alizarin crimson, sap green,
thalo blue, ultramarine blue

**1.** I make a thumbnail sketch to determine my values.

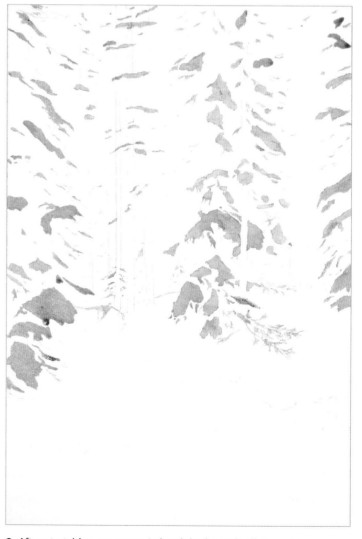

**2.** After stretching my paper, I sketch in the major lines and shapes. Then I put masking on all the branches with snow on them. I apply extra masking on the lower front branch, even though it will be a dark branch over dark-shadowed snow. I don't want the color blending over a fairly dark blue. There will be some overlap, but I want most of the branch color to match the trees behind it.

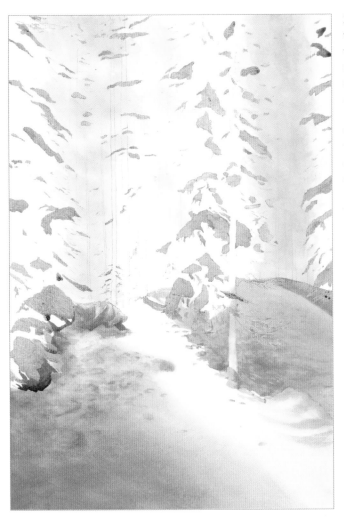

**3.** I first lightly erase the pencil lines in the snow that might show through where the paint is light. Then I use my large round brush to wet the areas where the sky shows through the trees. Next I mix some thalo blue and a touch of cerulean blue and paint in areas of blue sky. I wet the snow areas with water and then, using a mix of permanent alizarin crimson with a lot of water, I lightly put in the faint pink near the edge of the shadow. I drop in a little ultramarine blue and a touch of burnt sienna to create a warm blue-gray that blends next to and over the pink, slowly fading into the thalo blue and cerulean blue. As the paint dries I use darker mixtures of the colors where I see them creating a lot of the holes in the snow. It's critical that this part of the snow is dark enough in value to actually look like snow. Although it may look too dark blue right now, once the dark trees are in, it should look like white snow.

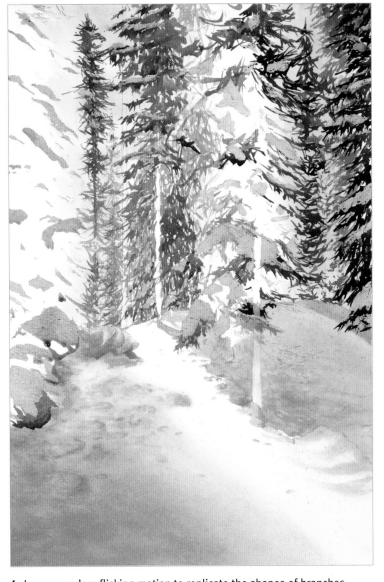

*Artist's Tip*

Achieving the right value with whites is critical so they will render like the subject you are painting. White is rarely pure white—it is almost always the complementary color of the light source or reflected colors.

**4.** I use a random flicking motion to replicate the shapes of branches and limbs of pine trees, keeping in mind the size, distance, color, and proportions of the different trees. I begin by mixing a warm olive green, using burnt sienna, ultramarine blue, and sap green. I try to get the lightest greens in first and then add some of the very darkest, almost black greens, where the branches are very dark. I use larger brush strokes up front on the bigger branches to give the illusion of closer trees.

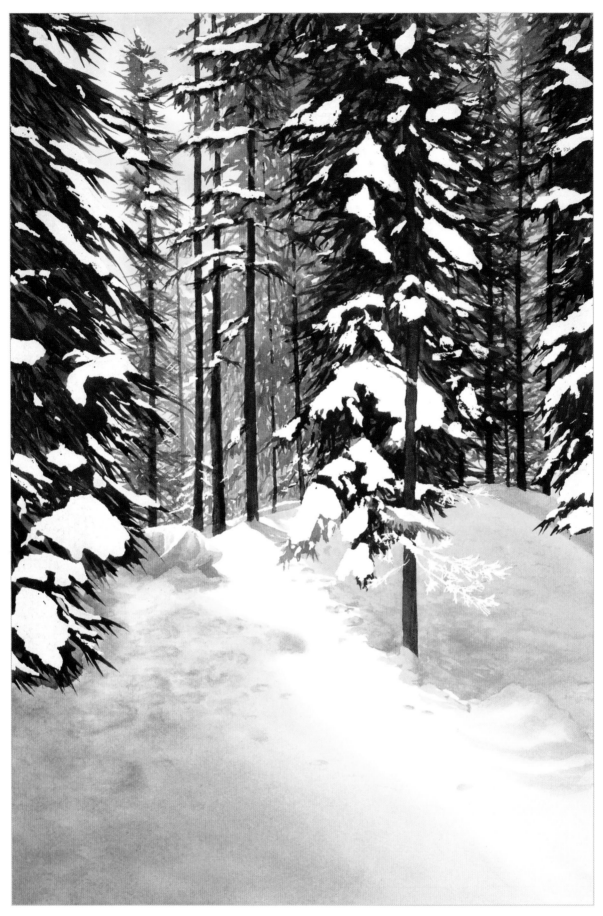

**5.** I continue working on the pine trees, painting the dark, closer trees first and then filling in the lighter background trees. The sunlit area has warmer greens than the shaded side, which has cooler greens. I paint in the tree trunks, leaving some places for the branches and making sure that the values are right for close and far trees. I make sure I have shadows under the snow patches and that the branches look right, and then I remove the masking.

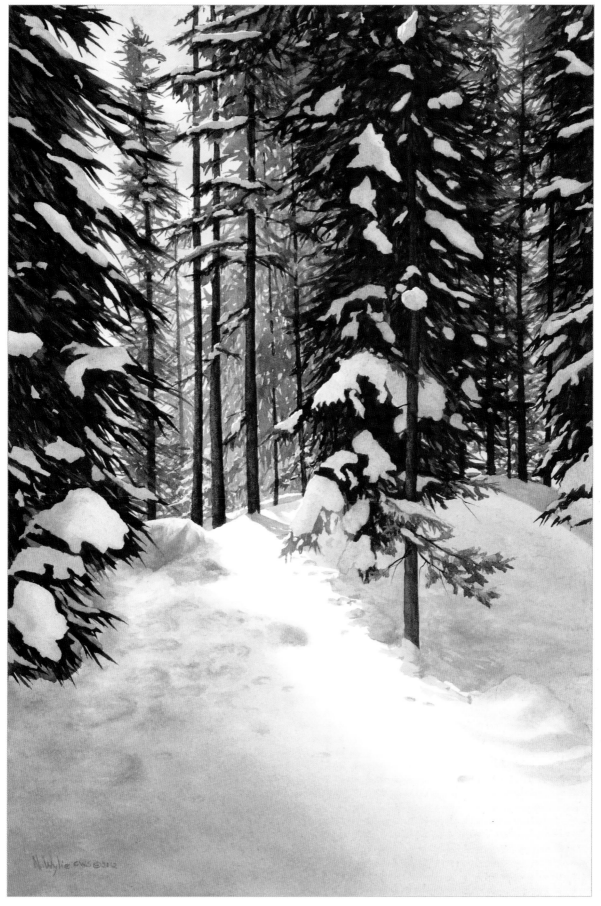

*Winter Light,* 20" × 13 ½"

**6.** I paint the snow patches with a mixture of ultramarine blue, cerulean blue, and thalo blue. Some patches have highlights that need a pure white edge where the sun hits them; however, most snow patches are flat with a little shadow. I go around each patch with dark greens, to clean up any rough spots or to reshape the snow patch. I finish the pine branches hanging in shadow.

# Painting Wet-into-Wet

I painted this after spending a day in the San Juan Mountains of Colorado in the summer. It had been raining and cloudy all day, but as the sun was setting, the clouds started to clear and the sun hit the mountains with a beautiful glow. I wanted to capture the beauty of the sky and work on a wet-into-wet landscape with a fairly simple foreground. Painting wet-into-wet can be difficult to control, but it is an exciting experience as the paint blossoms and blooms color. Learning how to control the timing of the painting with the wetness of the paper is the key to successful wet-into-wet painting.

## Palette

burnt sienna, cadmium yellow, lemon yellow, permanent rose, sap green, thalo blue, thalo green, ultramarine blue, yellow ochre

**1.** After stretching my paper, and while it is still wet, I lightly pencil in the top of the mountains and begin to brush in colors of the sky and a few clouds. I use diluted cadmium yellow for the sky, and then add thalo blue, some permanent rose, and mixes of permanent rose and thalo blue, trying to keep edges from forming. I use permanent rose and lemon yellow to brighten the colors in some of the clouds and the back row of mountains, and then blend in strokes of water to add a little pink into the foreground.

**2.** After the paper is dry, I sketch the simple lines of the mountains, valley, and trees. Some of the pink went farther down than I had planned, but it will add more reflected color to the foreground and make all the colors more cohesive.

**3.** I use a 2" wide brush to wet sections of the sky, and then reintroduce more of the same colors to darken the shadowed sides of some clouds. I work fast so that I don't create edges or back runs. I lift out the brightest areas of the sunlit parts of the mountains with a soft eraser and then paint the highlights and the mountains.

*Artist's Tip*

You can lift some paint with a soft plastic eraser by wetting the exact area with clear water, immediately touching it with a tissue (without sliding it), and then erasing the area. This will not work well with staining colors, but can get most other colors up quite well. This technique also works well when you need a thin line or small highlight.

*Evening Light* Show, 13 ½" × 21"

**4.** I work flat washes of ultramarine blue, thalo blue, and burnt sienna into the light greens that are a mix of thalo green, sap green, and yellow ochre. I paint the foreground trees last with the small spray bottle of water, dropping in paint and letting it run and create light and dark edges and suggestions of leaves. Once dry I go back in, doing more of the same, until I get the right illusion of texture. Finally I put a glaze of blue over the greens in the meadow to set it back into the distance. I also paint a glaze of bright pink over the back sunlit mountains to make them brighter.

# Taking Artistic License

In this lesson we'll explore changing the format of a painting. This fall scene has yellows, reds, and other colors, but it is kind of dull. I will show you how to use artistic license to change the color, size and composition of a painting from a photo reference. A good deal of the foreground in this photo is not interesting, so I decide to focus on the middleground and background. I crop my photo with strips of paper and adjust them until I like the composition. I then tape the paper in place on the photo.

## Palette

aureolin yellow, burnt sienna, cadmium red, cadmium yellow medium, cerulean blue, hansa yellow medium, mineral violet, perylene red, quinacridone magenta, raw sienna, sap green, thalo green, ultramarine blue, yellow ochre

**1.** This paper is heavy and fairly textured so I don't wet and stretch it but simply staple it down and tape the edges. I sketch in the essential lines and shapes and am ready to do the masking.

**2.** In this painting there are several areas that I need to mask in order to paint the surrounding area quickly and loosely. I want to be able to paint without worrying about lots of little key colors or critical edges that give the illusion of grasses, flowers, and leaves. I start by masking scribbly, bush-like shapes where the yellow leaves and bushes are in the distance. I then use my needle to indicate a few blades of grass and leaves in the foreground, especially in front of the big, dark pine tree. I use my masking paintbrush to add dabs of masking to give the illusion of trees around the edges of the sky and, where needed, give form to the trees. I can always create the texture with paint, and I might want these areas saved.

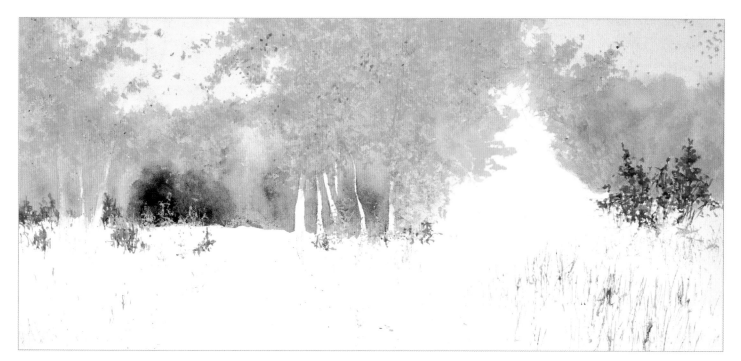

**3.** I paint the red foliage and leaves first. I add several other red leaves, using cadmium red, perylene red, and burnt sienna, across the painting to balance out some of the red color. I paint the sky with a dry brush, adding water to the edges to keep it soft and using a mixture of cerulean blue and quinacridone magenta to create a very slightly purple sky. Then, while it is still wet, I start putting in the sage green trees with a mixture of cerulean blue or aureolin yellow and a touch of burnt sienna. Next I work on the tan and purple distant trees with a mixture of raw sienna, ultramarine blue, yellow ochre, and mineral violet. I paint the last green tree in the distance with a mixture of sap green, burnt sienna, ultramarine blue, and thalo green. The yellow trees are a mixture of cadmium yellow medium and hansa yellow medium with raw sienna.

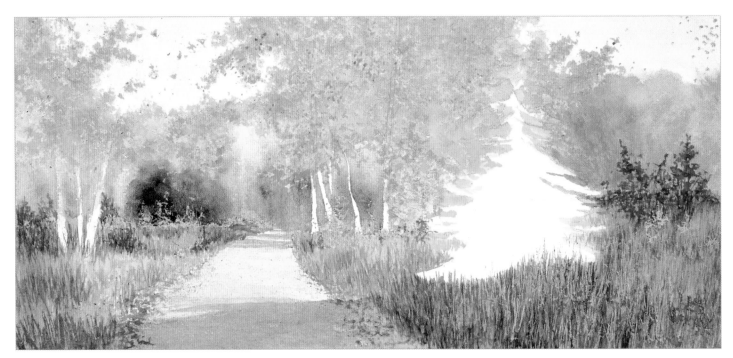

**4.** I paint the sunlit area of the path first, and then paint the shadows using mixtures of raw sienna, yellow ochre, ultramarine blue, and mineral purple. I add a little roughness by splattering paint with a toothbrush to create the texture of a dirt path. I add burnt sienna to the mixes to create the shadowed fallen leaves on the sides of the path. Next I work on my grasses, flicking up and down very quickly, first painting in the yellow and green grasses and then changing to the darker gray browns in the shadowed areas until all the whites are covered. I also put the sage color down in the grasses to repeat that color in the foreground. Finally I apply a glaze of yellow over the sage-colored trees to tone down the turquoise and make them relate better to the yellows in the rest of the painting.

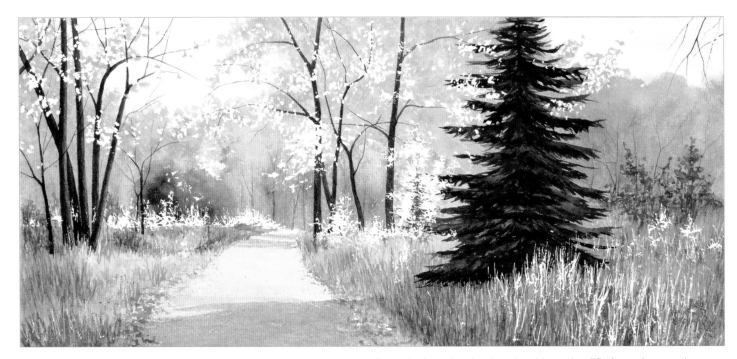

**5.** I paint each tree trunk according to their color and shape, trying to replicate the branches but keeping things simplified. I make sure the trees in the distance are lighter than the ones in the foreground, using burnt sienna and ultramarine blue. I work on the pine tree, keeping it light and dark as I see the highlights and shadows in it. I use burnt sienna, thalo green, and ultramarine blue. I use a rigger brush to achieve the fine lines of the branches and small tree trunks. I do another glaze of yellow and yellow ochre over the distant trees to give them a little more depth in color and value. Lastly, I remove the masking.

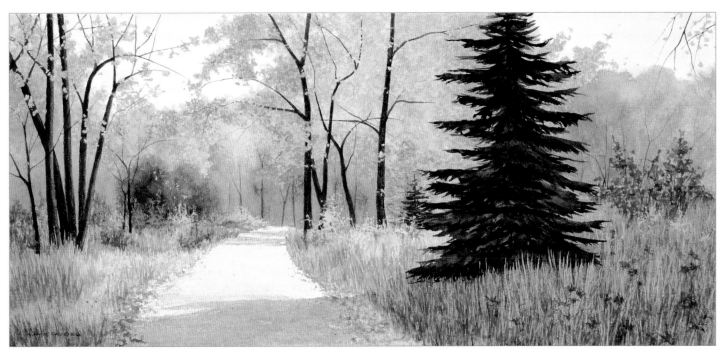

*Prospect Park Walk,* 11" × 24"

**6.** I paint the lightest areas in the grasses to get color in the white spots. I also paint the yellow leaves in the trees, paying attention to the lighter yellows. Next I soften, darken, and blend anything that looks hard-edged by dabbing with the brush. I fix the edges of the areas where I used masking. I decide that the foliage in the very back needs more red toward the left side in front of the green tree, so I change it from yellow to red. I also do several glazes and finally one dark yellow glaze over the purple and sage trees in the distance.

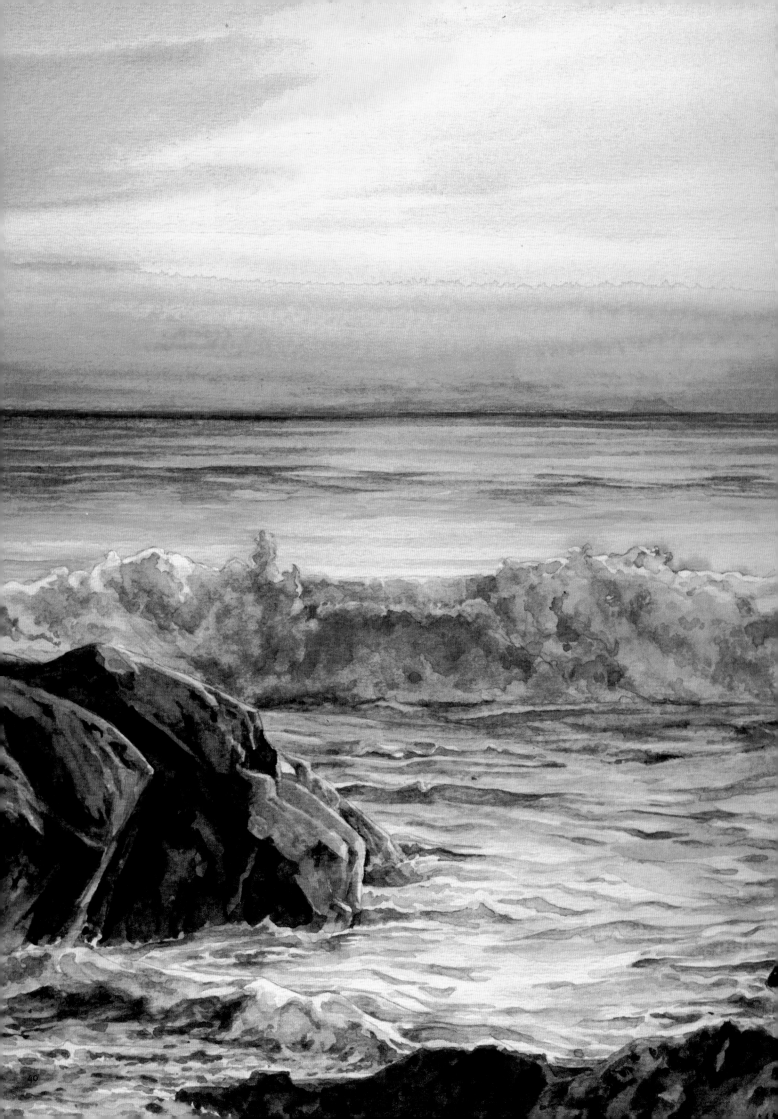

# CHAPTER 2

## Seascapes & Sunsets

### with Thomas Needham

Salty air, screeching gulls, crashing breakers, and golden, rippling waves.
I was fortunate enough to grow up on the beaches of Southern California, a
paradise where I could observe a kaleidoscope of colors and experience the
raw energy of the sea on a daily basis. As a watercolorist, I find the sky and
sea inspiring yet challenging subjects to paint. In this chapter, I hope to pass
along my passion for this wonderful art form. I will show you how to paint
luminous skies and various elements found in seascapes, such as rocks, sea
grass, and ocean foam.

# Seascape Elements & Techniques

On these pages, you will discover how to paint common elements indigenous to seascapes using basic watercolor techniques.

## Rocks

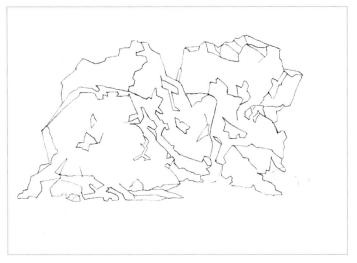

**1. Sketch** Using your imagination, create a contour line drawing of rocks with a 2H pencil.

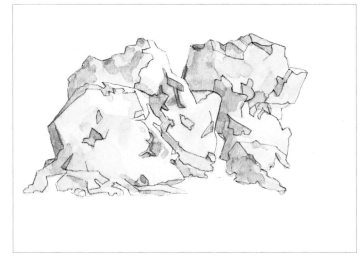

**2. Initial Wash** Begin giving your rocks some form and color. Using the wet-on-dry method, apply a light wash of Naples yellow over the rocks. Once the initial wash is dry, come back with a wash of burnt sienna to give the rocks shadows and shape.

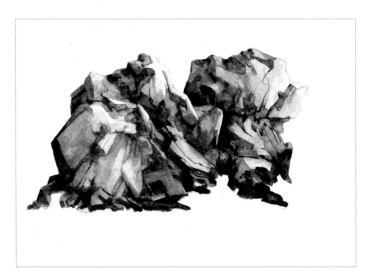

**3. Layering** Continue to layer wash over wash with various colors such as ultramarine blue, burnt umber, scarlet lake, and mauve to further define and shape the rocks.

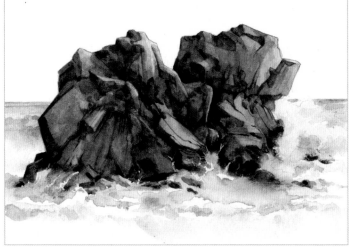

**4. Softening Edges and Finishing Touches** Finish by adding some surf lapping up onto the rocks. To soften the edges and achieve a bit of transparency, apply a small amount of water where the surf meets the rocks and then remove some of the pigment with a cotton swab. Lastly, using white gouache, paint streams of water running and bits of wave spray exploding off the rocks.

# Surf

**1. Sketch and Mask** Make a rough line sketch of surf and rocks. Next mask out the crashing surf and rocks, taking care to mask tiny droplets of spray flying through the air.

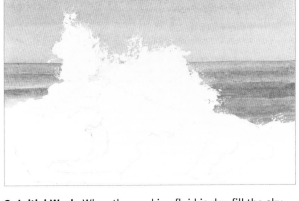

**2. Initial Wash** When the masking fluid is dry, fill the sky using a variegated wash of cobalt blue, ultramarine blue, and a bit of cadmium red near the horizon. Once the sky is dry, begin to brush in a wash for the ocean using cerulean, cobalt, and ultramarine blues, cobalt turquoise, and cadmium red.

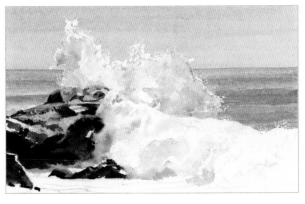

**3. Rendering** Before rendering the crashing surf, remove the existing mask and re-mask a few small areas in the foam. Pick a section of the splash or surf and work wet-into-wet in small areas. Dropping small amounts of blues, greens, and purples into the wet areas, let the colors bleed into one another. Give the rocks some structure by laying in various shades of blues and burnt umber.

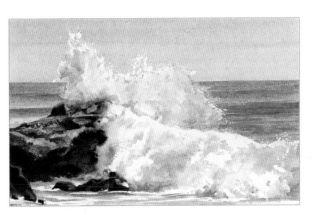

**4. Finishing Touches** Next remove the masking from the high-lighted surf areas. Take a wet cotton swab or brush and hit the edges where the surf meets the rock to soften the edges and create some transparency.

# Sea foam

**1. Sketch and Mask** Using a 2H pencil, sketch in detail the delicate lace pattern of the sea foam. Once the drawing is complete, mask out the sea foam in order to preserve the clean, white surface.

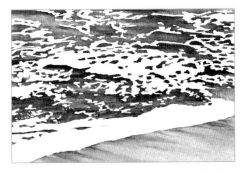

**2. The Wash** When you are finished with the wash, remove the masking. Using a round brush, apply a wet-into-wet-wash over the sand and seawater. Tackle the sand using a mix of burnt umber, ultramarine blue, cerulean blue, and a touch of mauve. For the seawater, use cerulean, cobalt, and ultramarine blues, cobalt turquoise, and mauve. Add touches of burnt sienna and yellow ochre to the shallow water areas.

**3. Finishing Touches** Apply a light wash of cobalt blue and mauve over the lace pattern of the sea foam to subdue some of the bright white.

# Sunset Techniques

Sunsets are all about the colors in the sky. In most seascapes or landscapes, the sky sets the mood and dictates the color scheme of the entire composition. The best way to paint a sky in watercolor is to use a wet-into-wet variegated wash. Mastering the art of wet-into-wet washes, however, requires patience, perseverance, and—most of all—practice. I embrace the challenge of painting sunsets that involve more than four colors, for the end result is clean, glorious color.

With wet-into-wet washes, the wet painting surface creates fluid runs, exciting mixtures, and soft gradations of color, which capture the softness of clouds and sky; however, achieving pillow-soft edges is no easy feat. If the surface or paintbrush are soaking wet, you lose control over the color. If they are too dry, the color will not spread. The following illustrations are examples of wet-into-wet washes that show various cloud formations and color schemes.

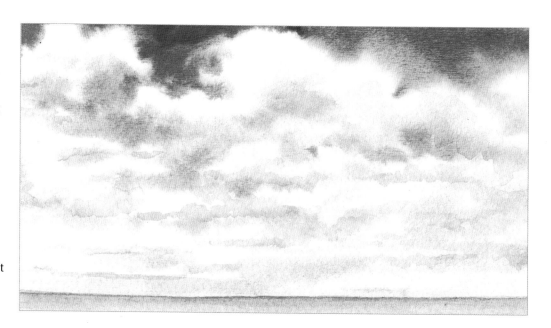

**Late Afternoon** Painting fluffy white clouds in watercolor requires painting the sky and not the clouds. Using a wet-into-wet wash, I begin at the top with ultramarine blue and work down the painting, introducing cobalt blue and cerulean blue as I go. Clouds appear larger at the top of the painting and shrink as they near the horizon. To give the clouds some dimension, I mix a gray value and apply it to their undersides. The temperature of the afternoon can be controlled through color. For a warm afternoon, spike the water with a touch of lemon yellow and paint light blues. For a cooler afternoon, use stronger and darker blues.

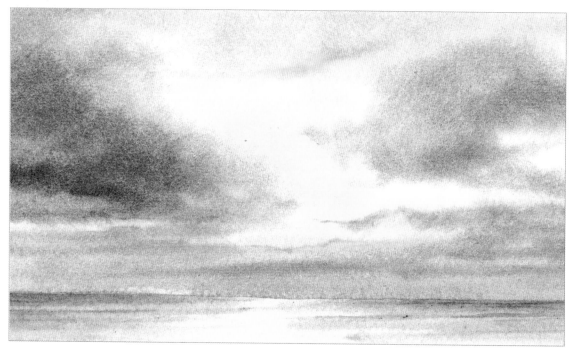

**Hazy** I use four colors (ultramarine and cobalt blue, raw sienna, and cadmium red) in a wet-into-wet wash to depict the sun breaking through a bank of hazy clouds. To form the clouds, use the ultramarine and cobalt blues and cadmium red. For the sun, add raw sienna and allow it to bleed and blend, giving a soft, hazy feel to the scene.

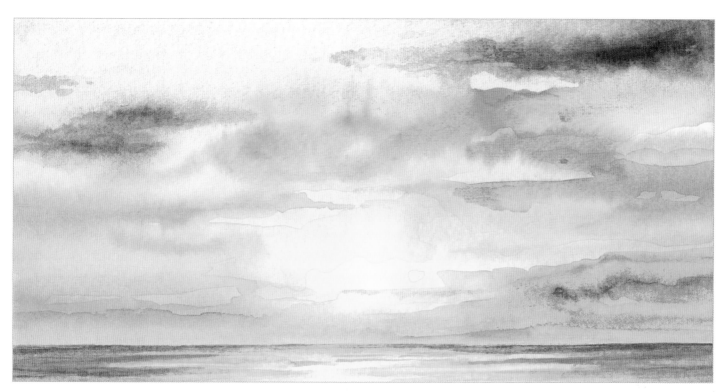

**Blazing** For this fiery sky I use a wet-into-wet wash of lemon yellow, cadmium orange, cadmium red, burnt sienna, cobalt blue, and ultramarine blue. With the exception of the sun's center, I wet the entire board before applying the paint. I surround the sun with lemon yellow, allowing it to spread out in all directions. I place a light coating of ultramarine and cobalt blues at the top of the board and allow them to bleed down. To form clouds, I layer mixtures of cadmium orange, burnt sienna, and cadmium red over the initial wash.

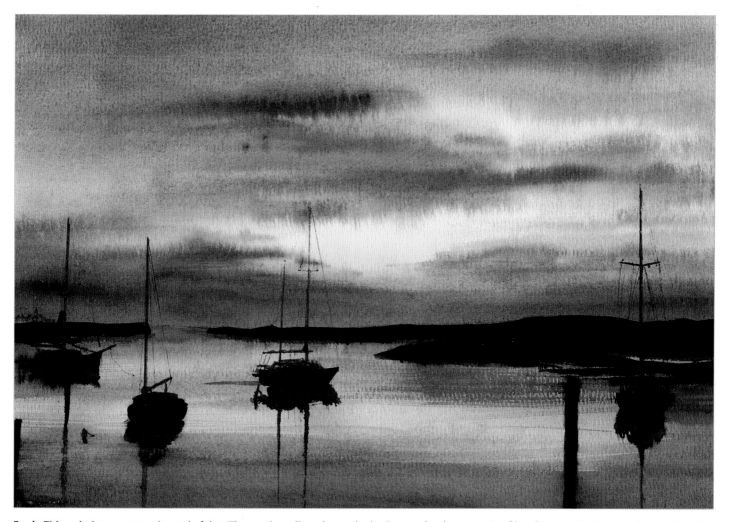

**Dusk** This painting captures the end of day. The sun has slipped over the horizon and only remnants of its glow remain. In a wet-into-wet wash, I apply the warm colors of the glow first, followed by the cool blues.

# Exploiting the Sunlight

I wanted this project to be challenging, so I searched my files for the perfect reference photo. I found what I was looking for in this picture of rolling surf in a cove just south of Point Mugu in Southern California.

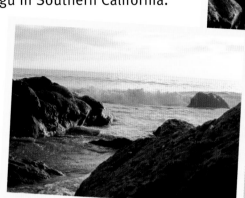

For me, there is no greater challenge than to paint a sunset and get all of the colors to blend perfectly. To make the composition more intimate, I used only a portion of the reference photo. I decided to give the sky more drama by warming up the color and changing the time of day to late afternoon.

## Palette

burnt sienna, burnt umber, cerulean blue, cobalt blue, cobalt green, mauve, Naples yellow, scarlet lake, ultramarine blue

**1.** Using a pencil, I lightly draw the horizon line first and then add the main elements in the painting: rolling surf, rocks, and a few dark waves. When the drawing is finished, I mask off a one-inch strip below the horizon line.

**2.** Working rapidly, I apply clean water to the entire sky area with a flat brush and start with a very light wash of Naples yellow. Next I load the same color onto a large round brush and apply it to the bottom third of the sky, taking care to add some to the outer edges of the clouds. I clean the brush and add burnt sienna to the lower portion of the sky and the clouds in the upper portion of the sky. Then I place horizontal strokes of cobalt blue in the upper sky, followed by a mix of cobalt and mauve for the main body of clouds. For the finishing touches, I add a few strokes of scarlet lake to the bottom of a few clouds. Once the sky is completely dry, I remove the masking.

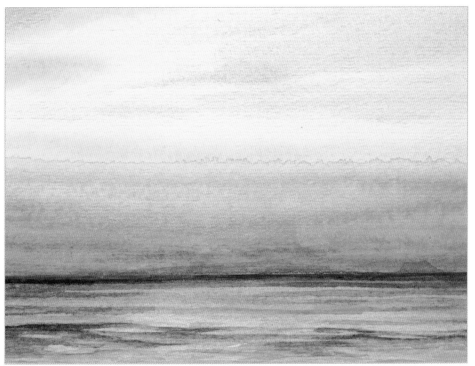

**3.** First I mask off the top part of the breaking wave. Then I add a wash of Naples yellow over the entire ocean. While still damp, I layer it with horizontal washes of burnt sienna, cobalt blue, and mauve. Finally I add darker values of these colors to the distant horizon.

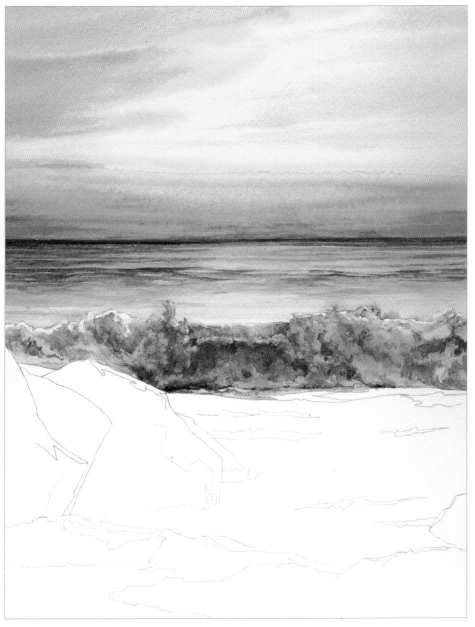

**4.** I begin working the top portion of the breaking surf where it is catching the most sunlight. I paint pale washes of Naples yellow overlaid with burnt sienna and scarlet lake. Most of the crashing surf is void of direct sunlight, so I paint it with cool washes of cobalt blue, mauve, cobalt green, and burnt sienna.

*Artist's Tip*
When painting with watercolors, a good sketch is essential. Oils and acrylics are forgiving; if you find yourself unhappy with the placement of an object, you can move it by painting over it. In watercolor, however, moving elements around like this is not an option. The paint is simply not thick enough to cover mistakes.

## Wave Detail

Working small areas and using a wet-into-wet wash establishes the turbulent surf.

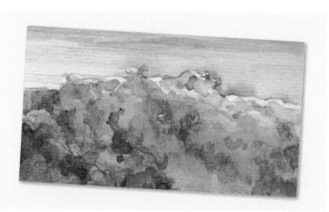

**5.** To capture the sun's warm glow on the water, I use a round brush and paint a wet-into-wet wash of Naples yellow over the entire water area in the cove. I immediately follow this with small touches of burnt sienna and scarlet lake. Once the initial wash is dry, I brush in wavy strokes of various blues, greens, and violets to establish the action and patterns of the smaller waves. The area right in front of the crashing surf is in the shade and calls for washes of cobalt blue and mauve.

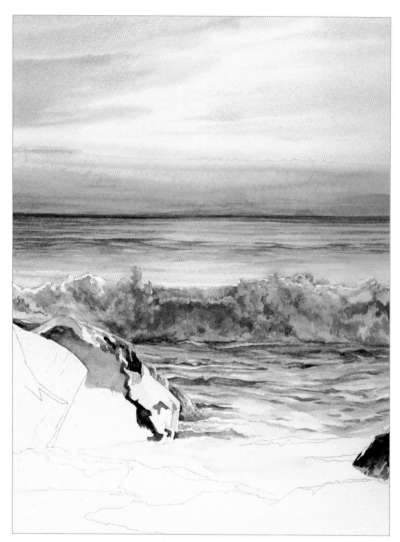

### Artist's Tip

A lot of watercolorists become disappointed when colors turn "dirty" from overworking wet-into-wet strokes with multiple colors. Creating clean yet complex colors is not a one-time process, and getting the proper effect requires patience and multiple layers of color. For this project, practice these rocks on another sheet of paper before adding them to the actual painting.

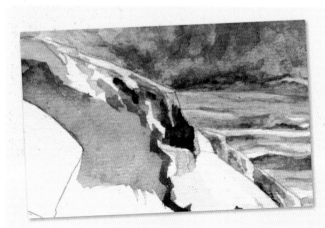

### Rock Detail

I give the rocks structure by layering one wash of color over another, beginning with the lighter colors first.

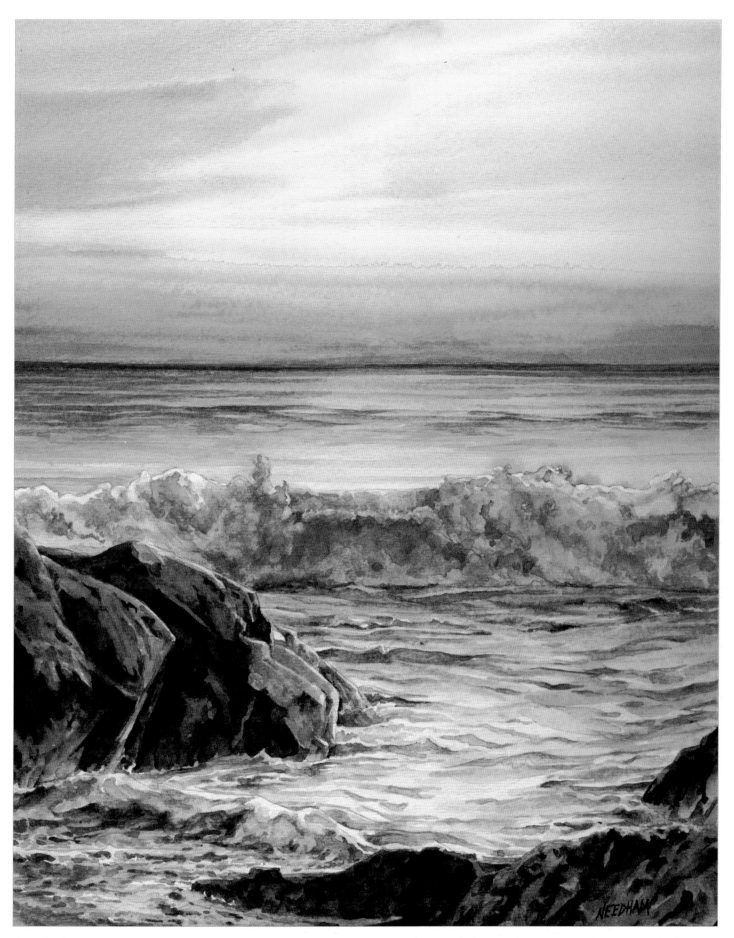

**6.** I paint the rocks with values and shapes that give them an organic structure, paying particular attention to the way the sun casts shadows and reflections. Layer colors such as burnt umber, Naples yellow, and burnt sienna as you see fit. To intensify the sun's golden glow on the rocks, I add a medium transparent wash of burnt sienna over the lighted surfaces. Finally I darken the value of the distant waves. Scan your painting to see if anything needs enhancement.

# Adding Shadows

I love painting lighthouses. These trusty beacons are captivating, for they are full of history and they nudge ships away from danger. My reference photo of the Monhegan Island Lighthouse on Maine's coast was snapped during the day. Although it's beautiful, it's not very exciting. I want to add some drama and mystery to the scene, so to accomplish this, I paint it as a night scene, with a full moon breaking through the clouds.

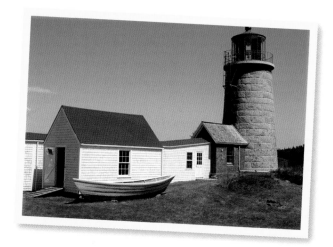

## Palette

alizarin crimson, cerulean blue, burnt sienna, burnt umber, Indian red, indigo, lemon yellow, Payne's gray, ultramarine blue, Winsor violet

**1.** When incorporating structures into a painting, it is important to have a detailed drawing. In order to avoid pencil marks, it is best to work out the details of the composition before committing the drawing to the painting surface. With the details of the composition worked out, I transfer a contour line drawing to my painting surface, using a 2H pencil.

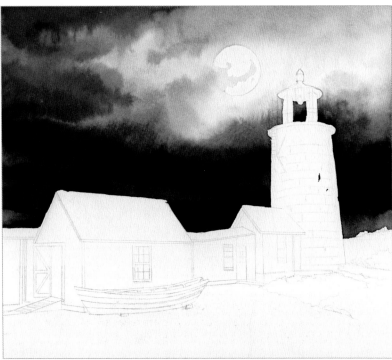

**2.** I mask all of the structures that protrude into the sky and the portion of the moon that is to remain white. Then I lay in the sky, using a wet-into-wet variegated wash consisting of lemon yellow, cerulean blue, Winsor violet, indigo, and Payne's gray. I begin the wash by wetting the entire sky surface area. Next I brush a small amount of lemon yellow around the moon to give it a bit of a glow. Working rapidly, I lay in small amounts of Winsor violet and cerulean blue near the moon. I paint the clouds with heavy amounts of indigo and Payne's gray. When the sky is completely dry I remove the masking.

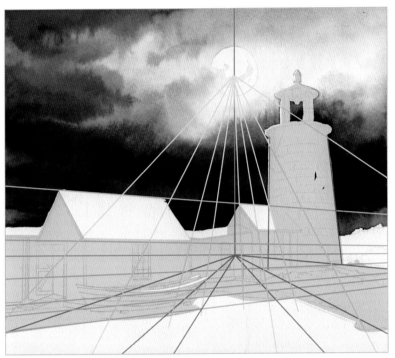

**3.** This step is quite challenging, so make sure you take it slowly and be patient with yourself. Before rendering the lighthouse and buildings, it is helpful to know where the shadows are going to fall. Our scene is backlit, with the moon relatively low in the sky, which makes painting the shadows somewhat challenging. To determine the shadows, I first need to establish eye level: this is the gold horizon line. Then, from the center of the moon, I draw a vertical magenta line that intersects with the gold horizon line. The point where these two lines intersect is called the *shadow vanishing point* (SVP). Draw light blue light rays from the moon's center to the roof edges and onto the ground. From the SVP, draw magenta lines to the light blue lines. Where the light blue lines intersect with the SVP lines on the ground is the length and direction of the shadow. Draw the outline of shadows lightly.

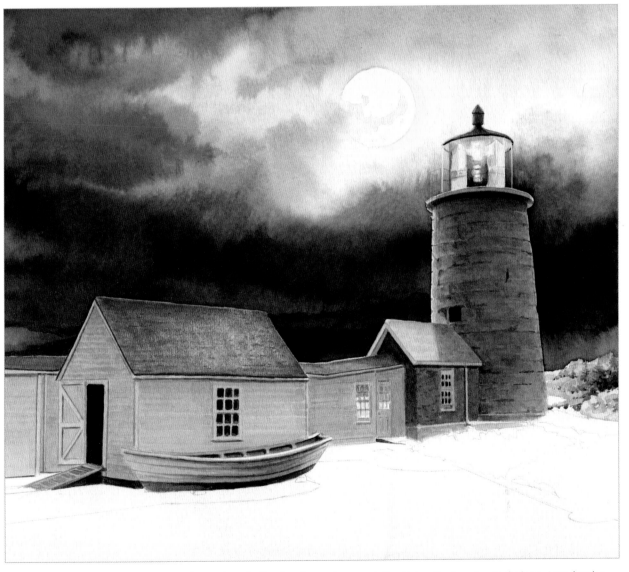

**4.** I add burnt umber, burnt sienna, Indian red, and alizarin crimson to my palette. Using the layering technique, I render the larger surface areas, such as roofs and building sidings. To obtain the proper value, a number of layered washes are required to build a rich tone. I add highlights on the roofs using a wet cotton swab, gently rubbing it on the roof area to remove just a tad of pigment.

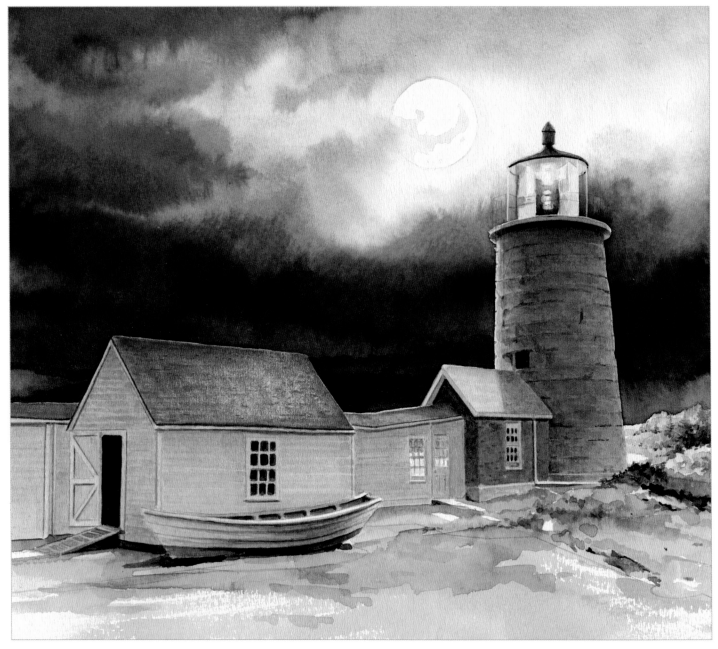

**5.** I mix some indigo with burnt umber and brush in a basic ground color, keeping it generally light so it contrasts dramatically with the shadows. I add a little Payne's gray into the mix to add some darker values.

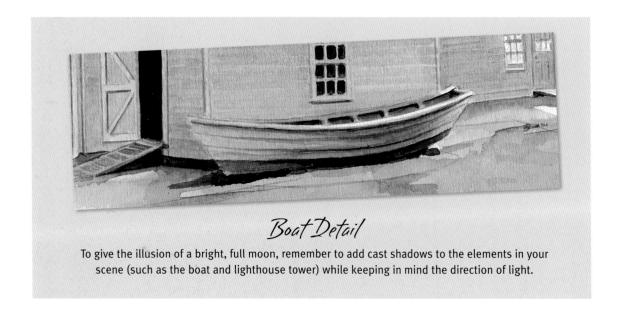

*Boat Detail*

To give the illusion of a bright, full moon, remember to add cast shadows to the elements in your scene (such as the boat and lighthouse tower) while keeping in mind the direction of light.

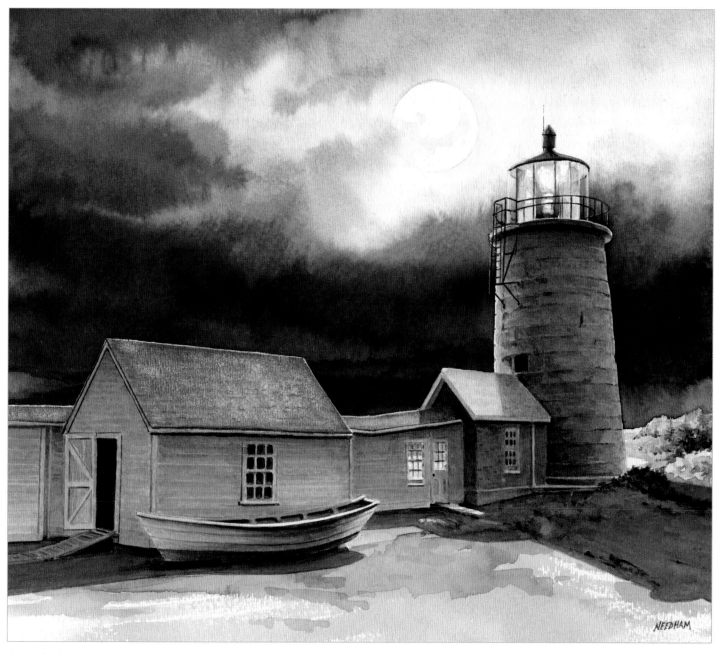

**6.** I lay in the shadows, using a mix of indigo and Payne's gray. I adjust the values on the lighthouse and sides of the buildings so they are dark enough to be dramatic. I add some final touches on the lighthouse by painting in the ladder and railings. Lastly I add a touch of white gouache to the center of the lighthouse light to make it even brighter.

*Moon Detail*

Keep the shapes within the moon simple and crisp.

*Building Detail*

The warm glow of interior lights through the window gives this building life.

# Rendering the Coastline

Just south of Point Mugu along California's famed Pacific Coast Highway, the sun's rays bounce across the sea and splash onto the cliffs of the surrounding coastline. I chose not to alter much from the reference photo; I like how the hills, coastline, and waves all lead the eye to a point in the distance. You'll find that the real challenge here is using watercolor to capture the scene's almost surreal golden glow.

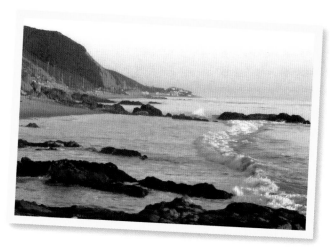

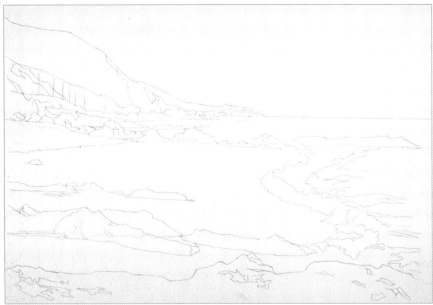

**1.** I use a pencil to lightly sketch a line drawing of the scene.

*Palette*
burnt sienna, burnt umber, cerulean blue, lemon yellow, mauve, permanent rose, raw sienna, scarlet lake, ultramarine blue

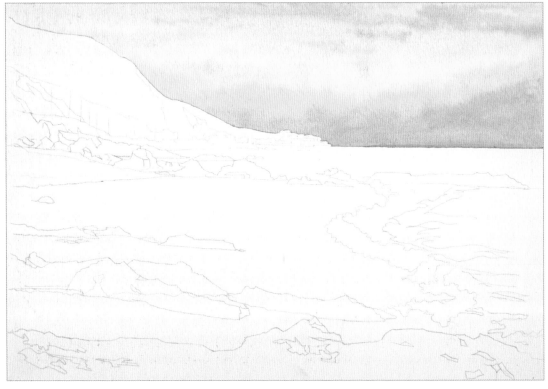

**2.** I start by masking off the hill and distant ocean. Then I begin a wet-into-wet wash with a layer of clean water over the entire sky area. Next I brush a coat of raw sienna from the horizon line to mid-sky. From here I introduce permanent rose, and then add cerulean blue near the top. Using a round brush, I finish the sky by adding a few clouds. For the lighter clouds I use a mix of raw sienna, cerulean blue, and permanent rose. For the darker clouds I use mixtures of raw sienna, permanent rose, and ultramarine blue. After the wash has dried, I remove all the masking.

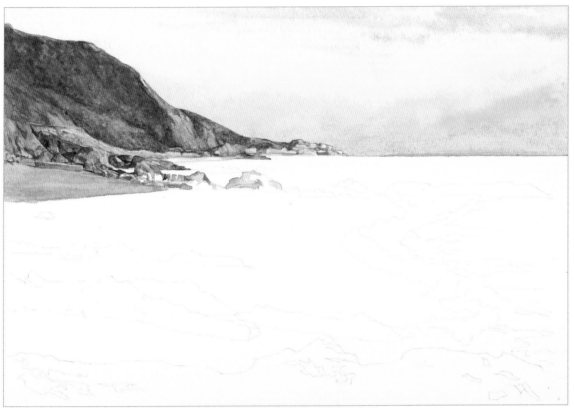

**3.** I bathe the cliffs in lemon yellow, followed by a wash of scarlet lake mixed with lemon yellow. Next I add a wash of cerulean blue and raw sienna over the vegetation on the hillside.

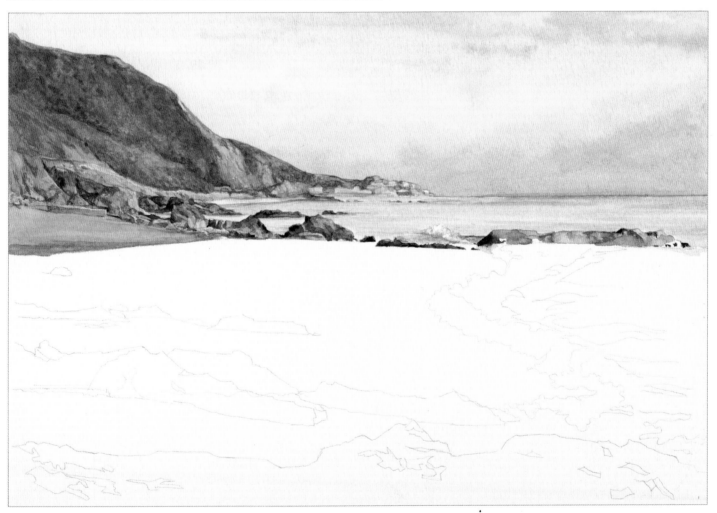

**4.** I begin painting the ocean, using a light wash of raw sienna. I follow this with light, horizontal strokes of permanent rose. Once the initial wash has dried, I come back over it with a wet-on-dry technique, using light touches of cerulean blue and a few strokes of permanent rose and ultramarine blue.

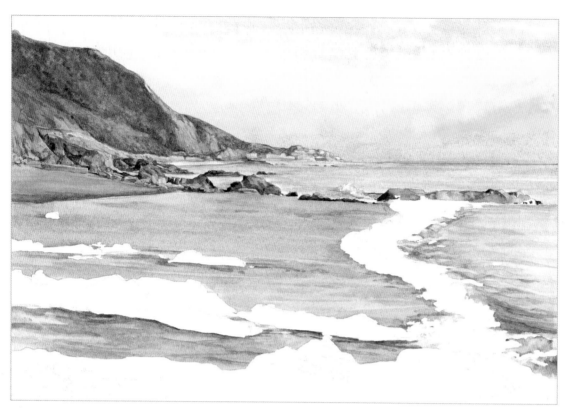

**5.** I mask out the foreground rocks and crashing wave. When the masking fluid is completely dry, I begin a wet-on-dry wash, using dark values of raw sienna, permanent rose, cerulean blue, and ultramarine blue. On the left side of the wave, your brushstrokes should appear to "pull" from the beach to the wave. To depict turbulence, sculpt the back of the wave with stronger and darker values. When the washes are dry, I remove all the masking.

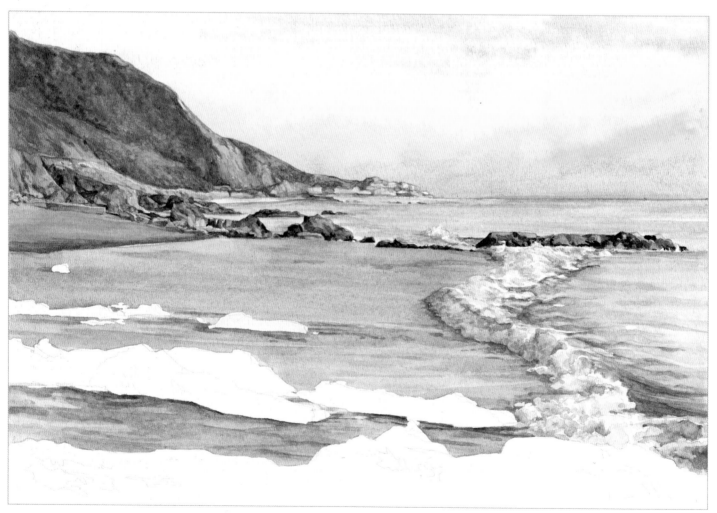

**6.** In order to give the wave some form, we need to establish its light and dark sides. Since the light side of the wave reflects warm colors from the late afternoon sun, I use a light wash of permanent rose and a mix of scarlet lake and lemon yellow. On the shady side of the wave I use a wash of cerulean blue mixed with permanent rose.

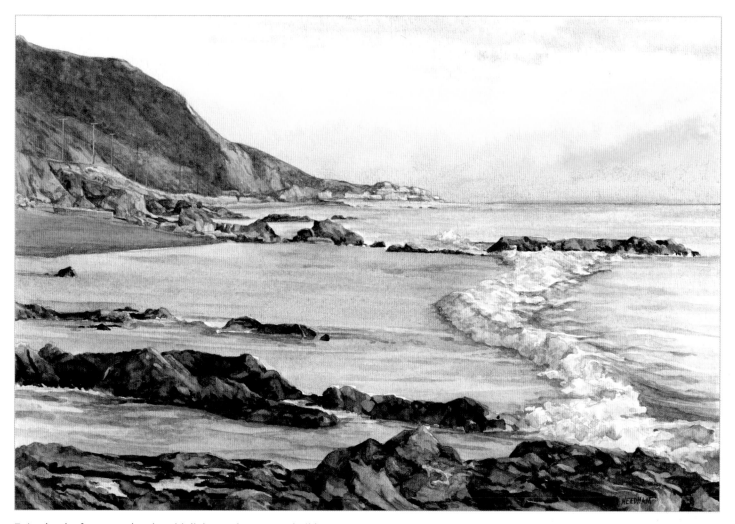

**7.** I paint the foreground rocks with lighter colors. Next I build structure into the rocks by adding darker values. I use a myriad of colored washes, layering one over another to obtain subtle changes. If you'd like, use a mix of white gouache and scarlet lake to paint the telephone poles.

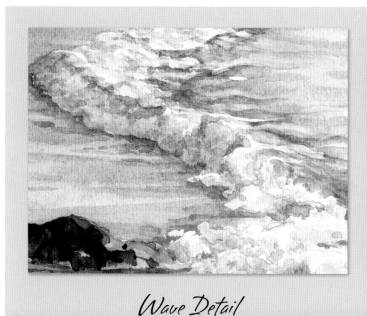

### Wave Detail

Notice that the backside of the breaking wave is painted with warm colors from the setting sun.

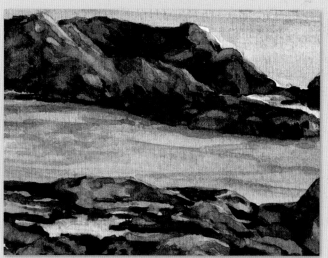

### Rock Detail

Observe that the surfaces on the rocks that face the sun are a warmer and lighter value.

# Painting from Imagination

For many a beachgoer, the definition of perfection is a day spent along the ocean's edge. From the throne of a beach chair, one can view the edge of the world and fill the senses with fresh air, the roar of the ocean, and the warmth of the sun. I did not use a photo reference here; I pulled the sky, sand, and sea from my imagination.

## Palette

burnt sienna, burnt umber, cerulean blue, cobalt blue, cobalt turquoise, Naples yellow, permanent rose, raw sienna, sap green, scarlet lake, ultramarine blue, white gouache

**1.** I sketch a line drawing of a beach chair, bag, soda can, and the horizon line.

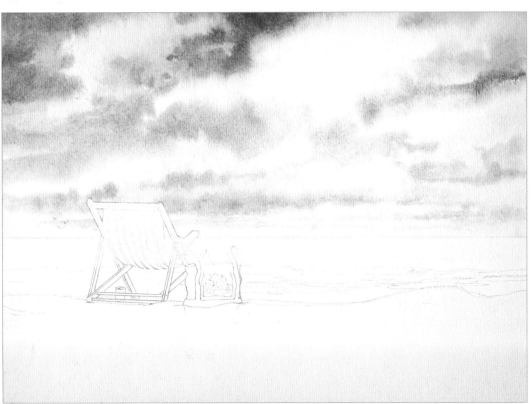

**2.** I start by placing masking fluid over the top portion of the beach chair and below the horizon line. Once the masking is thoroughly dry, I wet the entire sky area with a very light wash of raw sienna. Next I apply a wet-into-wet variegated wash, using a round brush. Starting at the top, I spread a mixture of ultramarine and cerulean blue over the sky, painting around the clouds. As I move toward the horizon line, I use more cerulean and less ultramarine. Finally I add a wash of cerulean, burnt umber, raw sienna, and ultramarine to the clouds to give them form. When I am satisfied with my sky, I allow it to dry, and then remove the masking.

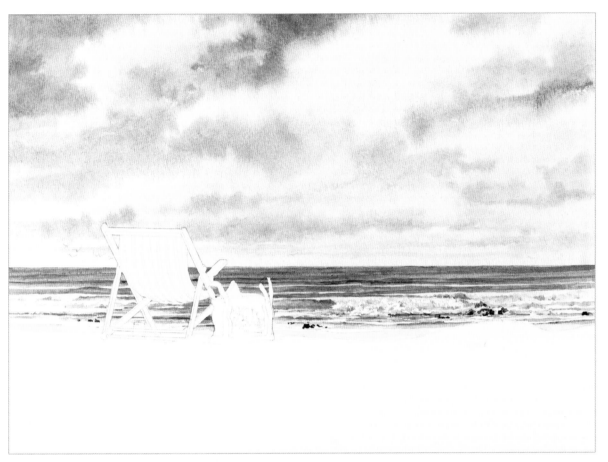

**3.** Next I'll work on the ocean. I begin by masking out the beach chair and bag. Using a round brush, I apply a wet-on-dry wash of ultramarine blue, cobalt turquoise, and burnt umber. I use darker values near the horizon and progressively lighter ones as the sea comes closer to the shore. To indicate waves I paint dark, horizontal lines in the distance, using a round brush. For the splash area of the breaking waves I use subtle value changes of blues and grays. Using burnt sienna, burnt umber, and ultramarine blue, I add a few rocks to the shoreline. Then I remove all masking.

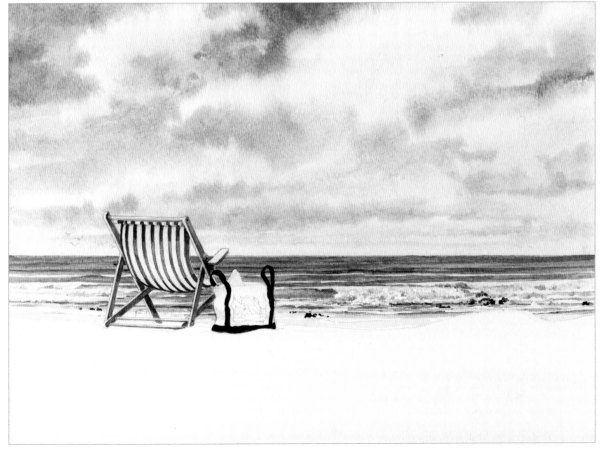

**4.** Using a round brush, I paint in the stripes of the beach chair with scarlet lake. I render the black straps on the bag with a mix of ultramarine blue and burnt umber.

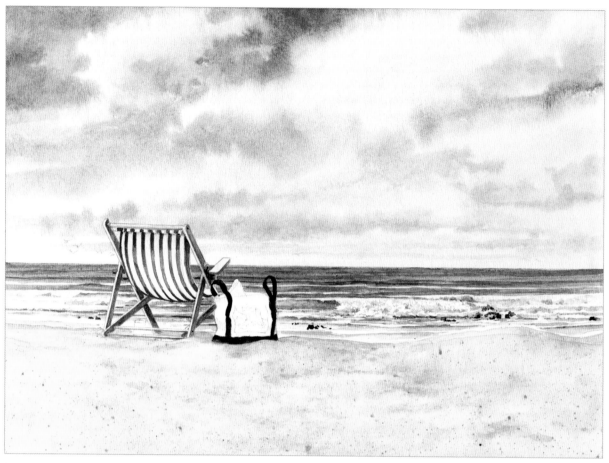

**5.** I cover the entire sand area with Naples yellow, raw sienna, burnt umber, and a pinch of cerulean blue. Then I cover the sky and sea with a paper towel to protect it. While the sand is still damp, I load a toothbrush with burnt umber. Using my thumb I flick the bristles of the toothbrush to produce tiny droplets of paint, giving the sand some texture.

**6.** I apply small amounts of water to the areas where I want to render grass, and then add raw sienna, burnt sienna, sap green, and ultramarine blue to the same areas. I use a craft knife to scratch the surface rapidly, producing tiny blades of grass.

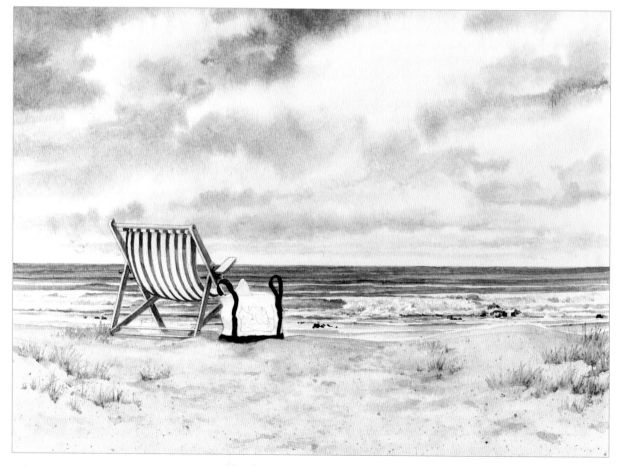

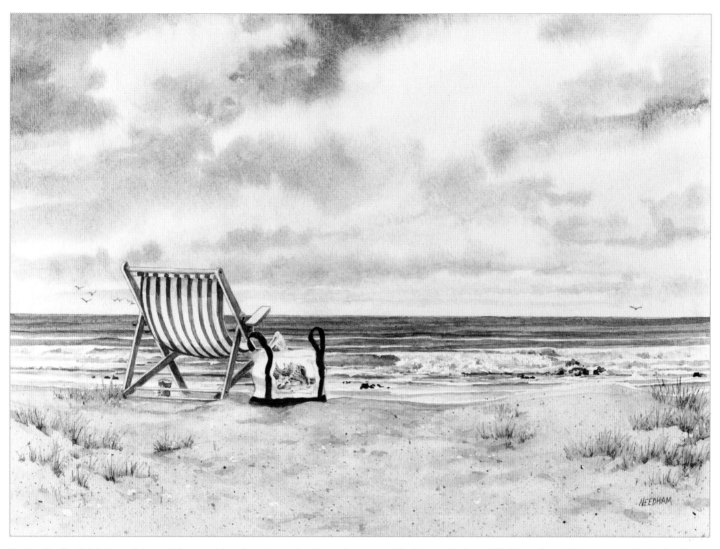

**7.** For the final detail work I use thin round brushes to render the soda can and design on the bag. I finish up by adding some gulls to the sky and a few blades of grass where necessary.

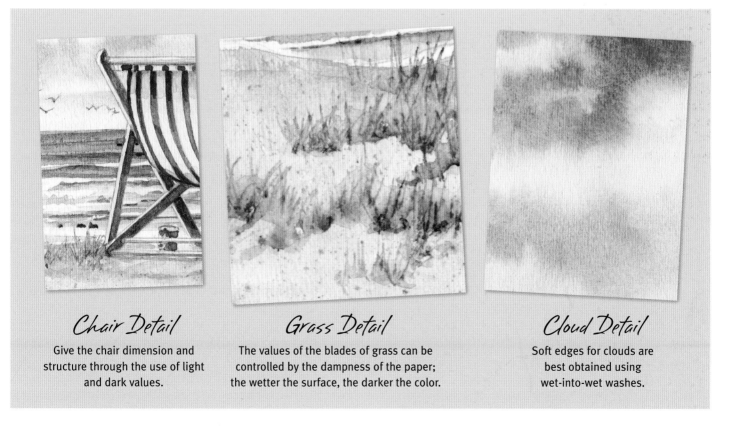

### Chair Detail
Give the chair dimension and structure through the use of light and dark values.

### Grass Detail
The values of the blades of grass can be controlled by the dampness of the paper; the wetter the surface, the darker the color.

### Cloud Detail
Soft edges for clouds are best obtained using wet-into-wet washes.

# Painting in Sections

This photo captures the kind of summer beach day that Southern Californians anxiously anticipate all winter. Here, five guys are enjoying the fact that one huge breaker is rolling in after another. I improved the mood of the day by using warmer colors and changed the color of the swimwear to add contrast and interest to the painting. I painted wave by wave, layer by layer, section by section. As such, this painting requires lots of masking and patience.

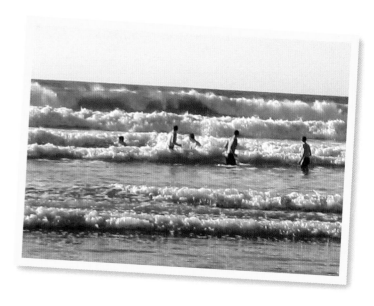

## Palette
burnt sienna, burnt umber, cerulean blue, cobalt blue, cobalt turquoise, lemon yellow, permanent rose, ultramarine blue, white gouache

**1.** I use a 2H pencil to create a line drawing of the scene, emphasizing small shapes.

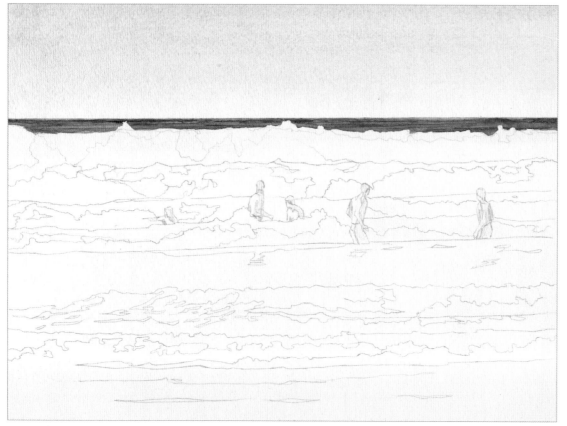

**2.** I mask a one-inch strip under the horizon line. When the masking is dry, I add a gradient wash of cerulean blue to the sky. I remove the masking when the wash is dry. Next I lay down masking along the top of the back wave. I apply a mixture of cobalt turquoise, ultramarine blue, and burnt umber to the distant ocean, using a wet-on-dry technique. Then I remove the masking.

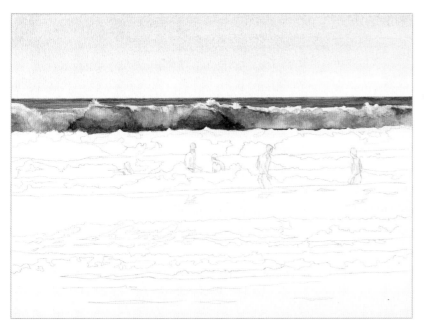

**3.** Next I mask along the top of the second wave. Working in small areas, I begin to render the most distant wave. Using subtle value changes and a combination of wet-into-wet and wet-on-dry washes, I add a myriad of blues, greens, and yellows to the first wave. Be sure to leave the top part of the wave white.

▶ **4.** I mask the heads of the swimmers and a one-inch strip under the second wave. Then I render the second wave in a similar fashion as the previous wave. I remove all masking. Next I mask out the five swimmers and render the third and fourth waves in the same manner. Once dry, I remove all masking.

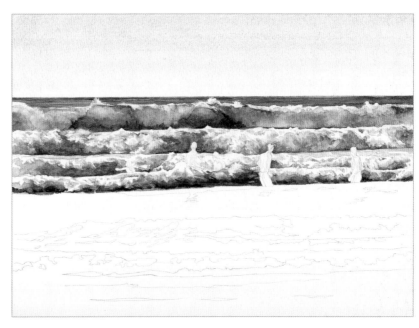

**5.** I make a flesh tone with lemon yellow and permanent rose and apply this color to the swimmers, using a thin round brush. When the flesh tones have dried, I give the swimmers form by adding darker values of burnt sienna and ultramarine blue. I use a mix of ultramarine blue and burnt umber for their hair. Paint their swimwear using bright colors of your choosing.

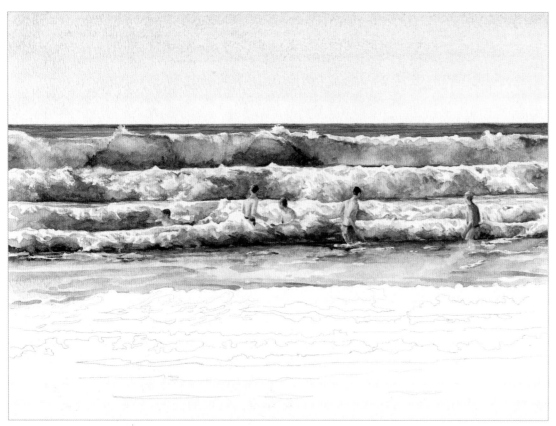

**6.** I continue down the painting, masking the tops of the small foreground waves and sea foam in the midground water. Once the masking is dry, I use a round brush to apply a wash of cerulean blue. When this dries, I go back and add horizontal washes of various blues. I remove all masking and apply very light washes of blue over some of the sea foam.

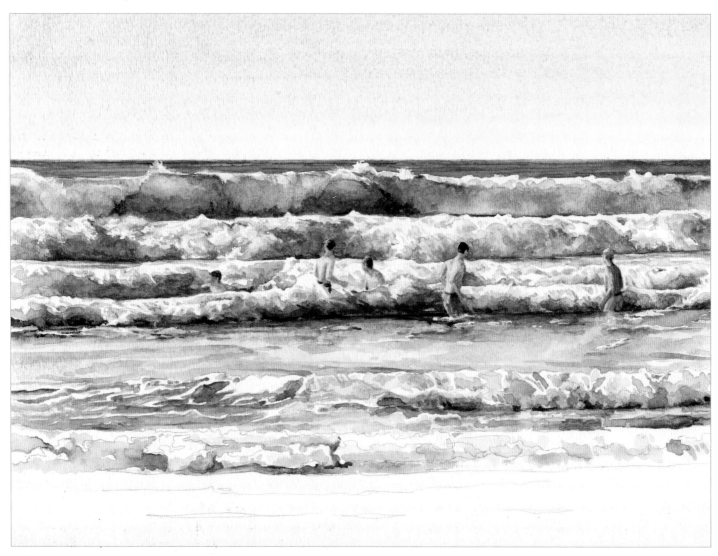

**7.** I paint the foreground waves using similar techniques and colors as in previous waves.

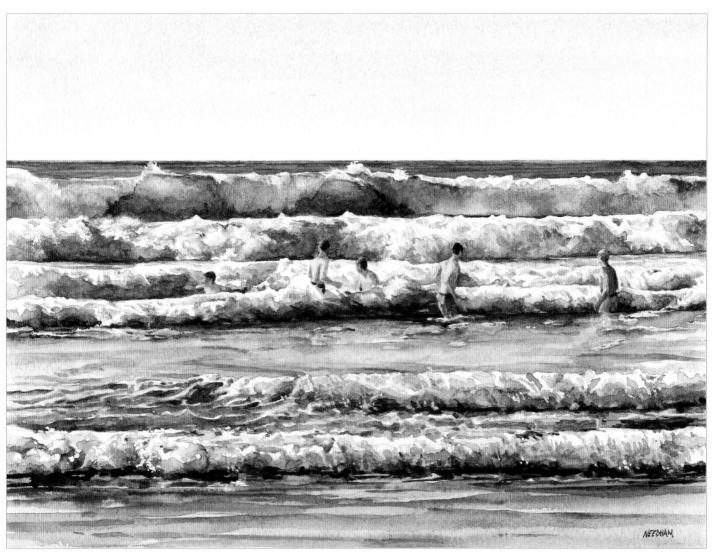

**8.** Using a round brush, I apply a wet-on-dry cerulean blue wash. Next I add layers of darker blues. Then I add a few horizontal brushstrokes of burnt sienna near the shadow of the closest wave and use various shades of blues and greens to fill in the still water in the foreground. Lastly I add a few specks of white gouache as needed for splash and spray.

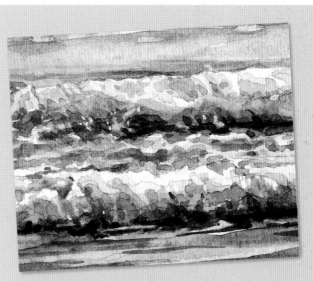

## Swimmer Detail

To give the swimmers' bodies form, be cognizant of where the sunlight is hitting them.

## Wave Detail

Notice that the tops of the waves are left white and subtle variations of blues are used to give the wave form and shadow.

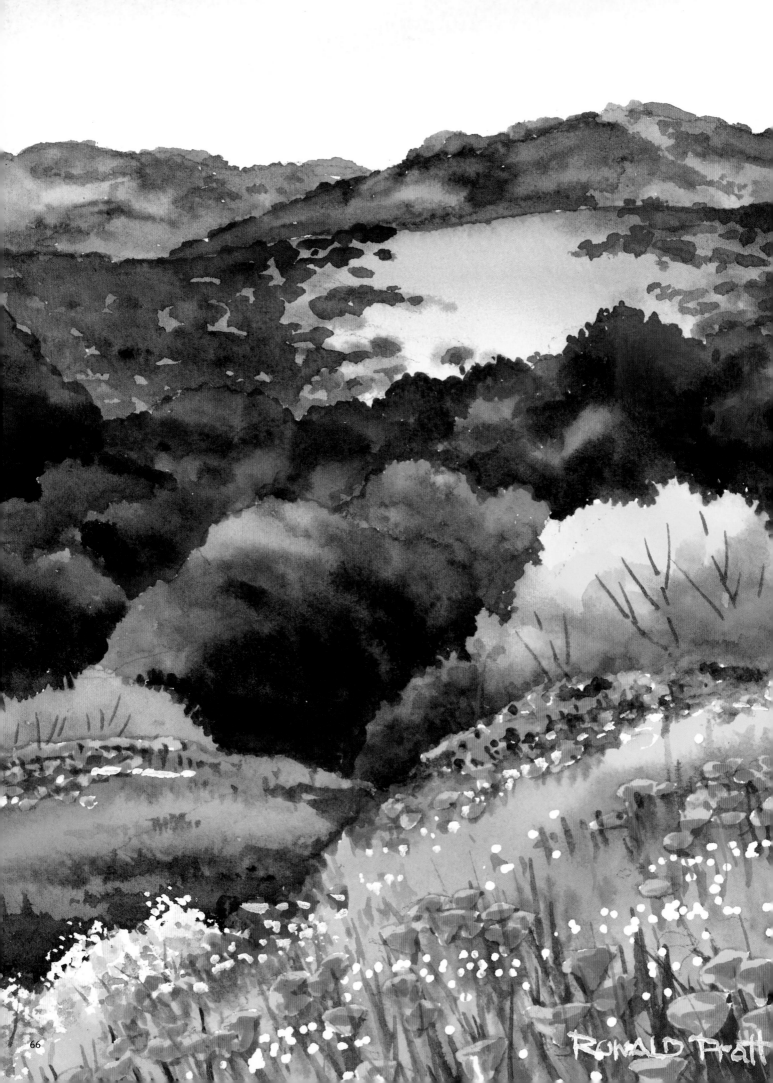

RONALD Pratt

# CHAPTER 3

## Landscapes

### with Ronald Pratt

One of my greatest pleasures in life is watching a beautiful watercolor painting emerge. It is magical and inspiring! As it slowly takes shape, my excitement grows. But I also know that there is no guarantee of success, no matter how well things start. This uncertainty is part of the watercolor painting process, and it makes a successful piece that much more rewarding. Be prepared to work hard if you want to reap the rewards of being a successful watercolorist. That said, I try to approach every painting with the main objective of having fun! In this chapter, I will demonstrate how to add vibrant color to landscapes, create depth and dimension, and render gorgeous trees and flowers.

# Injecting Color

Primarily a studio painter, I work from photos and value sketches. I use these tools as the start of an idea, rather than a strict template from which I must not deviate. Because it is a discovery process and not just copying, this allows me to have more fun with the painting. This reference photo was actually taken in the summer after the spring colors had faded, but I liked the compositional elements of the scene.

## Palette

burnt sienna, cerulean blue, Hooker's green, opera, permanent green #1, permanent green #2, permanent magenta, permanent yellow deep, permanent yellow lemon, thalo blue, ultramarine blue deep, white gouache, yellow ochre

### Artist's Tip
Remember that watercolor painting is an imaginative process, meant to be enjoyed and savored. Don't be a slave to the photograph! Have fun with the creative process and you will have a lifetime of enjoyment.

**1.** I start with a black-and-white value sketch to determine the value range and the placement of those values in the painting. I also establish the location of basic shapes. You can move elements around in the sketches to give yourself more options for the final design. I focus on the main components of the design, and do not worry about detail.

▶ **2.** Next I start a line drawing that defines where the elements go on the paper. Again, I keep this loose and focus on major components rather than detail. I find that the tighter the sketch, the more I feel compelled to follow the drawing, regardless of what my design instincts tell me is happening on the paper.

**3.** With the drawing complete, I mask out the blossoms on both the foreground tree on the left and the midground trees on the right. I use natural sea sponges to quickly and effectively stamp in a natural-looking blossom pattern. I use a larger sponge for the foreground tree and a smaller sponge for the midground trees to achieve the proper scale of the close-up larger blossoms and distant smaller blossoms. Test your sponge on a piece of scrap paper to determine the right amount of liquid mask and the right amount of pressure to stamp, and rotate the sponge as you stamp for varied patterns.

**4.** Once the mask is dry, I paint a colorful wet-into-wet wash over the entire painting. After wetting the entire paper with a 1" flat wash brush, I paint thalo blue and cerulean blue on the sky area. I mix a little opera with permanent magenta and paint behind the masked-out areas for both the foreground tree and the midground trees to create some background blossom color. For the tree on the left, the background hills, and the midground trees, I use Hooker's green, burnt sienna, and permanent green #2. In the meadow area, I flood in generous amounts of permanent yellow lemon with a touch of permanent green #1. For the dirt road, I use a little yellow ochre and burnt sienna for an earthy tone. Because this is a wet-into-wet wash, the colors move, blend, and do some unexpected things. This creates more color variations than if I tried painting each element separately.

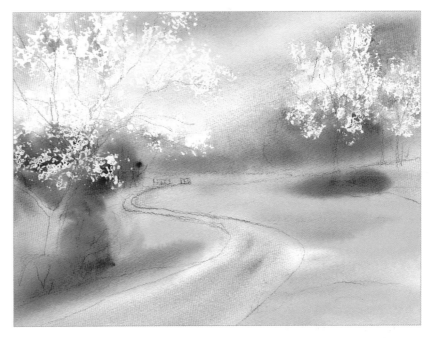

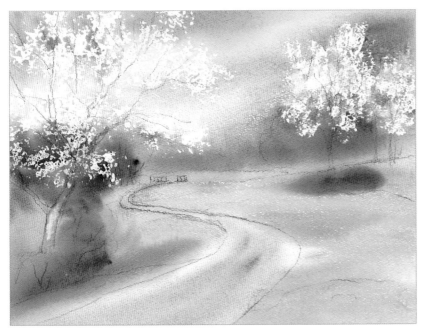

**5.** Once the first wash is dry, I take a small section of a sea sponge and start masking out the wild mustard blossoms in the meadow. The secret to masking over color is to make sure the initial wash is completely dry to prevent the mask from lifting off too much color when removed. By masking over the permanent yellow lemon, I have an initial yellow color already in place for the wild mustard when I remove the mask toward the end of the painting. Try to create more horizontal clusters of blossoms in the meadow by using a thin layer of the sponge. Adjust these blossoms with a small brush and mask as needed. I also mask the trunk of the foreground tree on the left to keep as a negative shape in the painting.

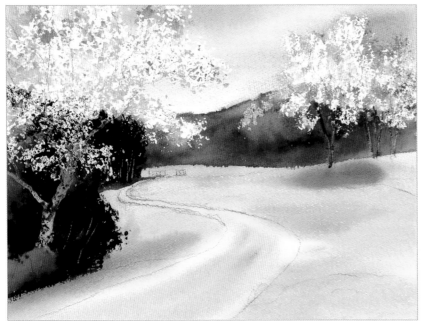

**6.** Next I mix Hooker's green, ultramarine deep blue, permanent green #2, burnt sienna, and a touch of permanent magenta for the primary dark values. I paint the trees and bushes on the left, as well as the background hill. I scrape out a few branches in the foreground bushes and tree trunks for the midground trees while the paint is wet. This adds variety to painting by creating some negative shapes, as well as positive shapes, for the structure of the trees and bushes.

**7.** Next I wet the entire meadow with water, avoiding the road and surrounding areas. Using a wash brush, I flood this wet area with Hooker's green, permanent green #1, and permanent green #2, using horizontal strokes. As this wash is drying, I stamp in some of the foliage texture for the wild mustard plants with a small sponge, using the same combination of colors. This creates soft texture. As the paper dries, I continue stamping to create texture that is more pronounced and has a harder edge. The contrast between the soft and hard edges adds variety. I add some grass-like strokes with a rigger brush, making these vertical elements smaller toward the back of the meadow.

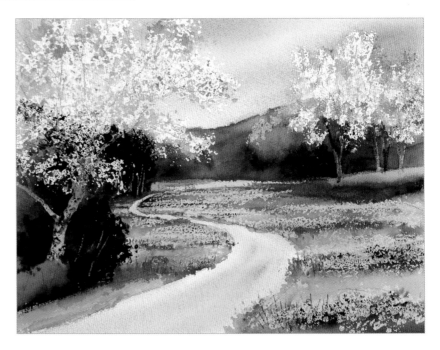

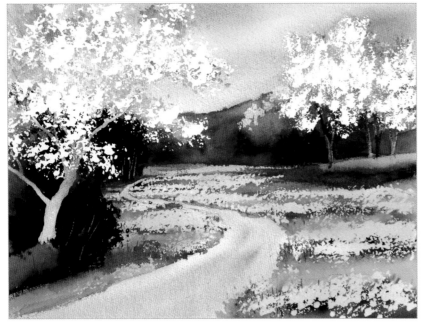

**8.** Once the entire painting is dry, I remove the masking fluid. At this point you should be able to see the painting starting to take shape. This is where painting really becomes fun! It is no longer just in your imagination—you can start to see it on the paper.

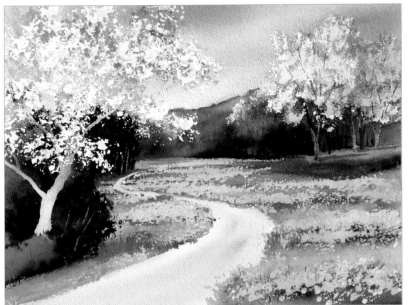

**9.** With a sea sponge, I pick up a little opera and add some pink blossom color to the foreground and midground trees. I add a touch of permanent magenta in a few places to add depth and variety to the blossoms and prevent the trees from looking flat. Don't try to "fill in" the white blossom areas. Add color to the entire tree, so some color is stamped over the white areas and some falls on areas already painted. Be sure to leave some of the blossoms white for sunlit highlights. I add more permanent yellow lemon and permanent yellow deep to the wild mustard blossoms with a small sponge. Then I stamp in some green shadow areas under the mustard blossom clusters to add shape and height to the plants.

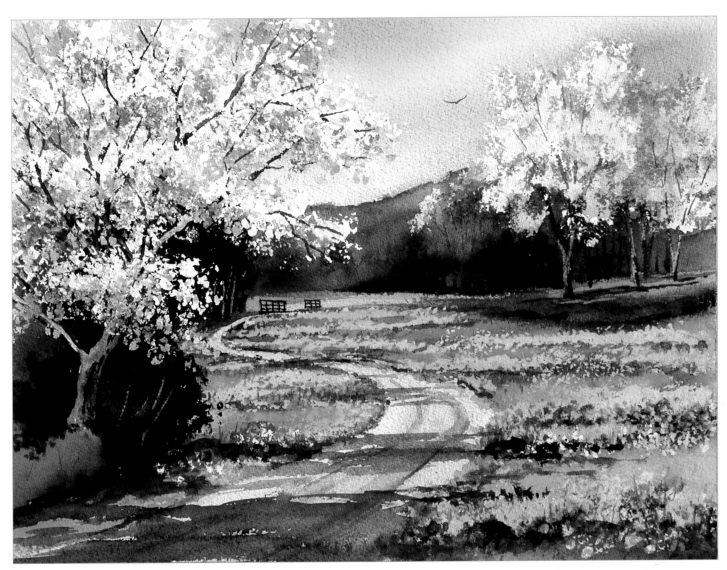

**10.** I use a medium round brush and a rigger brush for the trunks and branches. Burnt sienna and ultramarine blue deep creates a rich dark brown that can be varied in color from browner to bluer for variety. I mix and use a lighter brown on the sunlit side of the trees and a darker brown on the shadow side, making sure the branches seem to disappear and re-emerge from behind clusters of the blossoms in the trees. I add a hint of additional tree trunks in the midground trees, as well as the cluster of trees to the left of the pedestrian bridge. I paint the bridge guardrails with a small brush. Then I add more tracks in the dirt road and pull a few shadows across for drama. I adjust the edge of the road with the small brush to give it a rough, rural look. I mix a little opera with white gouache and tweak the blossom clusters as needed with a sponge and a small brush. Lastly I add a soaring hawk for the finishing touch to this beautiful spring scene.

# Creating Soft & Hard Edges

As a watercolor painter, I am always watching for possible painting subjects. I never know when I might see an interesting tree that would fit nicely into one of my paintings, or a hawk gracefully soaring in the wind, or an intriguing path in the woods. I always carry a small digital camera that fits in my pocket. While gold panning with friends in the California foothills, I came across this scene of an old bridge spanning a Sierra stream. The scene was tranquil and beautiful, so I pulled out my camera, took a photo, and continued on my adventure. I'll make a few tweaks to make it a well-designed painting.

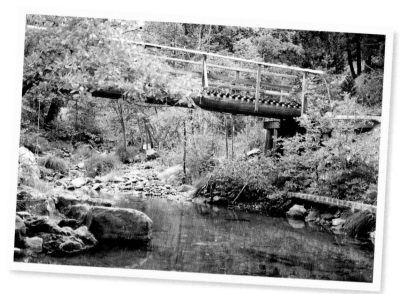

## Palette

burnt sienna, Hooker's green, permanent green #1, permanent green#2, permanent yellow lemon, thalo blue, thalo green, ultramarine blue deep, yellow ochre

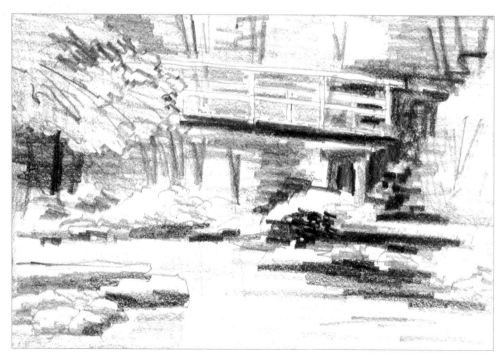

**1.** Even though I plan to work closely with the original photo, I take time to do a quick value sketch to familiarize myself with the subject and the composition. With the value sketch I carefully plan my light, medium, and dark values and compose the main elements. This sketch focuses on the main components of the scene without worrying about details that can be worked out later during the painting process.

**2.** I start with a line drawing directly on my 300-lb. cold-pressed watercolor paper, focusing on the main elements. Then I mask out areas of the painting that I want to save—the visible portions of the bridge and its supports. Use an old, small nylon bristle brush for masking and rub a little soap into the bristles first for easier cleanup when you are done. Be as patient and careful applying the mask as you would applying paint. What you mask out is what you will see when the mask is removed. Make sure your edges are clean, crisp, and accurately reflect the subject you are masking.

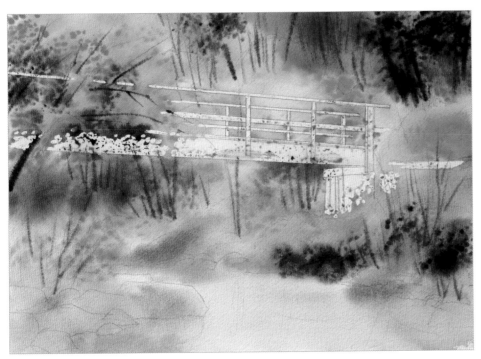

**3.** When the mask is dry I apply a colorful wet-into-wet wash to add some background color and to start blocking in some of my shapes. I use thalo blue and thalo green in the cooler shadow areas and Hooker's green, permanent green #1, permanent green #2, and permanent yellow lemon in the sunlit areas to achieve depth and variety. For the rocks and soil on the stream's edge and the foreground rocks on the lower left I use burnt sienna, yellow ochre, and ultramarine blue. While my wash is wet, I use a sea sponge to stamp in foliage texture for some of the trees and bushes, using the same colors on top of the initial colors. I paint in some of the trunks and branches with a rigger brush. By working wet-into-wet, everything stays soft-edged, which will provide a nice contrast to the hard-edged details I will apply later.

*Artist's Tip*

Don't worry about details at this early stage unless you are masking something detailed. Watercolor paints tend to take off in their own direction, and by focusing on the primary design components first, it's easier to adjust as needed when you start putting down paint.

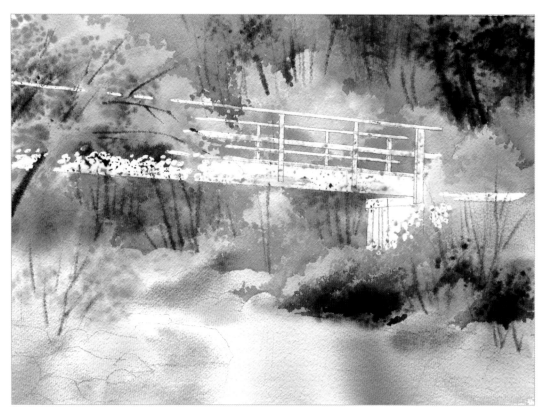

**4.** When my initial wash is dry I set up some sharp edges on trees, bushes, and rocks at the edge of the stream. I use a small brush to stipple foliage texture where I want these edges, based on my colorful wash. I work with the background colors and enhance the soft edges into some hard edges with my brush. I am careful not to try and "outline" an entire tree or bush but show only parts of their edges. In a forest scene we only see parts of trees and bushes that make up foliage clusters, so that's what I attempt to duplicate.

*Artist's Tip*

Don't be afraid to experiment. Variety is the spice of life in painting. An array of textures, color, value, and edge treatments is what makes this painting exciting. Give it a try, and remember to have fun!

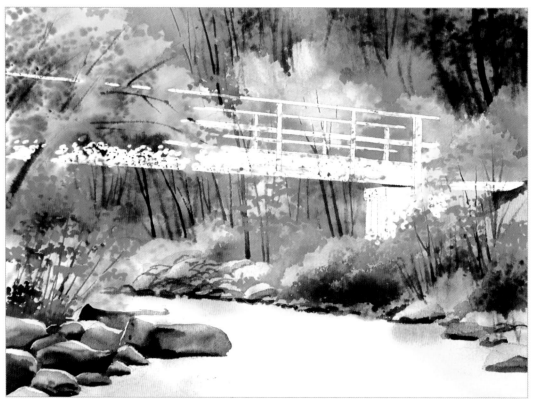

**5.** Next I want to add more foliage and details to the rocks, tree trunks, and branches. I continue to add foliage with more stippling and by sponging on dry paper. This hard-edged texture brings the foliage into clearer focus. I also begin to work on the rocks that line the edge of the stream, using yellow ochre, burnt sienna, and ultramarine blue. I merely suggest rocks in the distance with a few swipes of my rigger brush, but I want more detail in the foreground rocks. I wet each of these rocks individually and drop in light, medium, and dark value color to show shape, texture, and variety. I add more tree trunks, branches, and some structure to the bushes with my rigger brush.

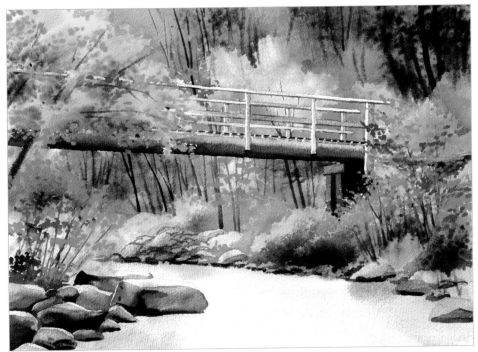

**6.** I allow my painting to dry completely and then remove the masking fluid from the bridge. I work a variety of earth tone colors into this wood bridge, using yellow ochre, burnt sienna, and burnt sienna mixed with ultramarine blue. I keep the railings lighter for contrast against the forest behind. I use burnt sienna and the dark brown mixture to paint the bridge suspension, making it progressively darker underneath to create shape and shadowing. For the support structure at the right I also use burnt sienna and my dark brown mix.

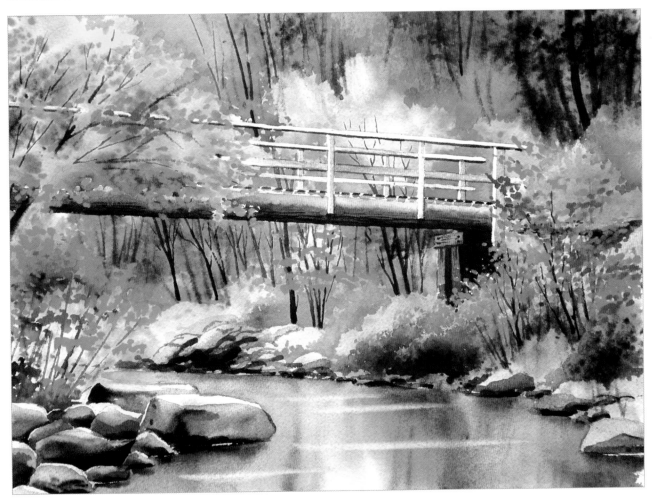

**7.** With my 1" flat brush I wet the entire stream with clean water. Picking some of the colors of the trees, bushes, and rocks I carefully drop colors into the water area close to the shoreline. I also add some of the bridge colors to the water. Then, after cleaning my flat brush and wicking out most of the moisture with a tissue, I carefully pull several brush strokes straight down from the far edge of the stream to the bottom of the page. I clean my brush and repeat the process, working all the way across the stream and pulling only several strokes before re-cleaning the brush. This creates a soft reflection in the water. Be careful not to pull color into the rocks at the lower left. I add the suggestion of reflected trunks and branches in the water with my rigger brush. While this area is still wet, I lift a few horizontal ripples out of the water with a ½" flat brush that has most of the moisture wicked out. After stepping back to observe my painting, I make a final pass to sharpen some edges, add more color, and refine details.

# Adding Elements

I came upon this scene while hiking in the Sunol Regional Wilderness park in the San Francisco Bay area. I like the flat meadow with its dry grasses and winding dirt road set against the backdrop of foothills, as well as the pattern of trees and bushes on the hills. The horse corral adds a nice human element to this natural scene, and I decide to play that up even more by adding a farm building and a few old wooden fence posts along the road.

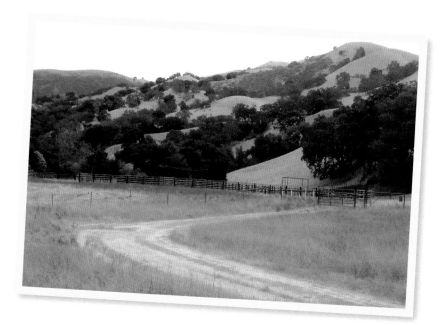

## Palette

burnt sienna, cerulean blue, Hooker's green, opera, permanent green #1, permanent green #2, permanent magenta, permanent yellow lemon, ultramarine blue deep, white gouache, yellow ochre

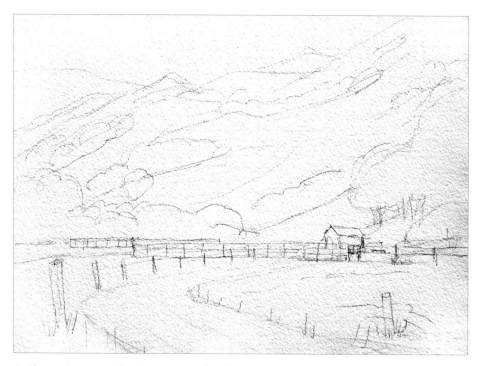

**1.** After making a quick value sketch, I do a line drawing on 300-lb. watercolor paper, keeping it loose and free of details. I mask the wooden fence posts and some of the corral fencing with masking fluid and a small nylon bristle brush.

## Artist's Tip

Coat your masking brush with a thin layer of soap first. The soap prevents the mask from drying too quickly on the bristles and makes for easier cleaning at the end.

**2.** Once the masking fluid dries I wet the entire paper and flood cerulean blue and ultramarine blue into the sky area and the lower right corner for balance. I also paint a thin wash of magenta on a few areas in the background hills and in the meadow behind the dirt road.

**3.** I let my first wash dry completely. Then I do a second wash with yellow ochre, burnt sienna, permanent yellow lemon, magenta, and Hooker's green. I want to create some rich, varied background color in the hills and the meadow, over which I will add detail later. This colorful wash adds variety but also acts as a unifying factor for the painting.

**4.** With my medium round and small round brushes, I start to paint some of the tree clusters along the upper ridge of the foothills. I use burnt sienna, permanent green # 1 and 2, Hooker's green, magenta, and yellow ochre. I try to replicate the shapes I see in my reference photo, painting some as clusters of trees and bushes and some as individual trees. I make sure to paint the trees slanting uphill to indicate the slope of the terrain. Make sure you vary the color, size, and value of the clusters to add visual interest.

**5.** Next I start painting the larger midground trees at the base of the foothills behind the corral. I use the same colors and brushes from step 4, but I make these trees larger. Notice how the break in the line of trees allows a visual opening through which the viewer's eye can travel into the hills beyond. Remember you are painting a cluster of trees and not a series of individual trees.

**6.** Between the ridgeline trees and midground trees I start filling in more of the foliage growth, following the slope of the hills upward. I start with the larger trees to the right and behind the corral, using the same color palette and brushes I used for the other trees. These are even large in scale, so I add in some trunk and branch detail, along with bigger shapes.

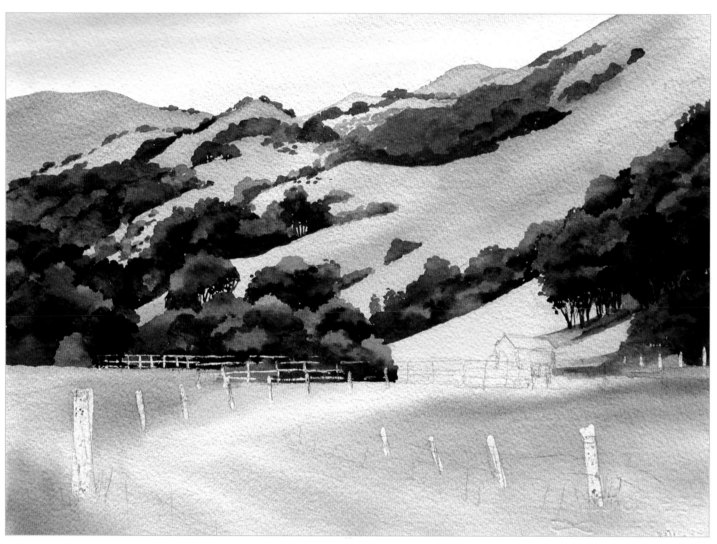

**7.** Starting on the left of the foothills, I start to paint more tree clusters. I make sure the scale gradually changes from the midground trees to the ridgeline trees. This helps create depth and variety, which are important to keep a painting from becoming monotonous.

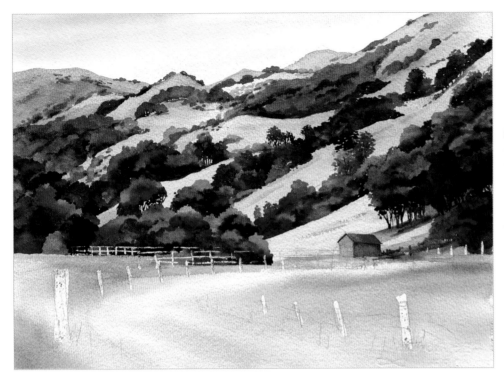

**8.** I finish painting the hillside growth, checking for patterns by squinting my eyes to blur detail but show basic shapes. I also paint the small farm building in the clearing, which is the focal point for the painting. From the farm structure I start to paint out into the open meadow in the foreground, visually tying the two areas together with color and value.

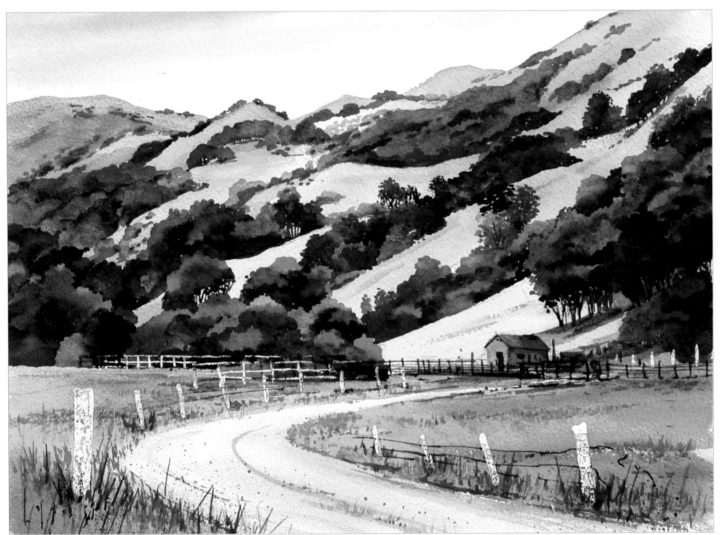

**9.** Now it's time to start work on the meadow and road in the foreground. Using my 1" flat brush, I start adding color to the grassy meadow with yellow ochre, burnt sienna, magenta, and a little Hooker's green. I darken the grassy area but leave the dirt road light in value to make it stand out from the field. While this wash is wet, I add some detail grasses and weeds with my rigger brush. I use a medium round brush to add more detail in the meadow and a small round brush to paint some of the corral fencing and a few strands of barbed wire dangling from the fence posts.

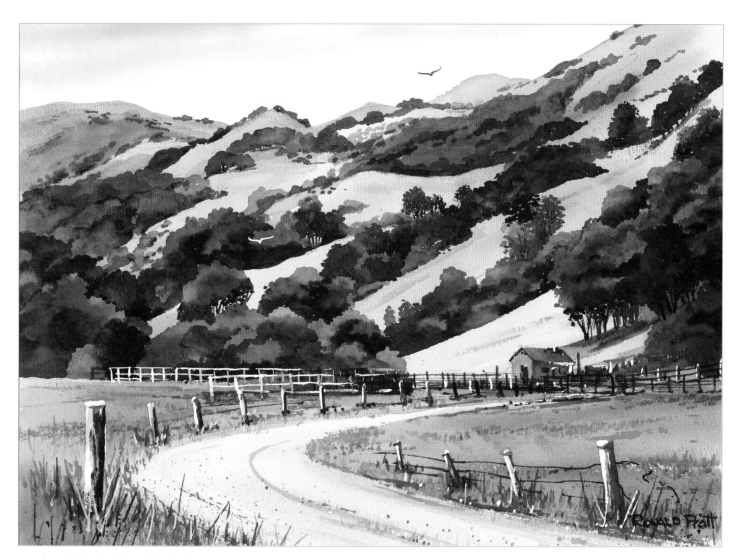

**10.** The painting is almost finished! I remove the masking fluid from the paper with a masking fluid pickup. I paint the wooden posts with a small round brush, giving each a shadow side and a sunlit side. I also finish the corral fencing. Then I tweak the grass at the base of the wooden posts with a rigger brush. I add a splatter of paint in the road to suggest dirt and gravel. I make a final pass around the painting with a little white gouache to add a few accents and details.

# Conveying Depth

I love painting the California foothills. I shoot a lot of photos whenever I'm out walking, knowing that later I can edit, delete, or crop on the computer when I have more time to study the photos for painting ideas. I only need a photo to spark the germ of an idea to run with. You don't need postcard-perfect scenes—just inspiration! I like this scene because it has an easily identifiable background, midground, and foreground—three elements that convey

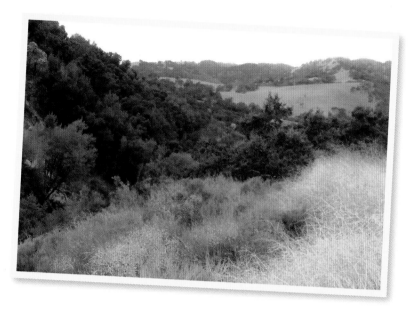

depth in a painting. Although this photo was taken in late summer when the hills were in their "golden" phase, I want to infuse it with more color by painting the scene as if it were early spring, when the California poppies are in full bloom.

## Palette

burnt sienna, cerulean blue, Hooker's green, opera, permanent green #1, permanent green #2, permanent red, permanent yellow deep, permanent yellow lemon, ultramarine blue, white gouache, yellow ochre

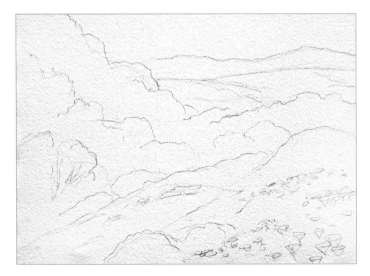

**1.** After completing a value sketch, I create a line drawing of the scene with a soft pencil and transfer it to my watercolor paper. I keep the drawing loose and focus on basic shapes, except for the areas I plan to mask. I want these to be more precise because once the mask goes on they are locked in place. I mask out a few wildflower shapes in the foreground hills. Then, with a small nylon brush, I carefully mask some of the poppy flowers, some blossoms, and a few small white flowers.

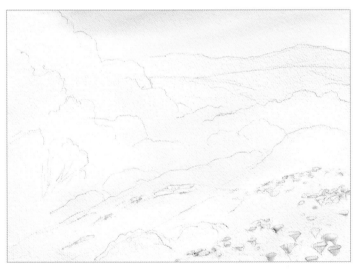

**2.** I wet the entire paper and flood in a little ultramarine blue and cerulean blue in the sky, as well as a wash of yellows and yellow ochre in the hills for a warm undertone. It's okay if a little yellow bleeds into the sky or a little blue bleeds into the hills. One of the purposes of the first colorful wash is to loosen the painting from the start by not trying to paint each area separately.

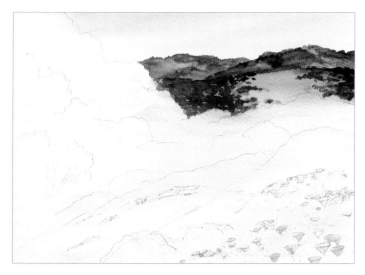

**3.** I start working on the background hills with my ½" flat and medium round brush, using a mixture of Hooker's green, permanent green #2, ultramarine blue, cerulean blue, burnt sienna, and yellow ochre. To give the impression that these hills are in the distance, I focus on painting only shapes of the vegetation. I also use less contrast and cooler, muted colors by toning down my paint with a bit of blue and mixing the colors instead of using pure color. This gives the hills the impression of being "pushed back" in the scene.

**4.** Next I work on the midground hills, which are darker in value and tie the background and foreground hills together. With my medium and small round brushes, I begin on the right side and start chasing a wet edge across the page, using Hooker's green, Hooker's green mixed with ultramarine blue, burnt sienna, permanent green #2, and yellow ochre. I start on the right because I am left-handed, but if you are right-handed it might be easier to start on the left. Move continuously across the page without going back into what you have painted, and thoroughly rinse your brush each time you change color. My focus is on the top and bottom edges. I'm looking for treetop edges at the top and edges that suggest one tree disappearing behind another at the bottom.

*Artist's Tip*

"Chasing a wet edge" gives you hard edges at the top and bottom of the area you are working—dry paper makes a boundary. The colors in the middle, however, blend together as if you were working wet-into-wet.

**5.** I continue painting foliage in the midground hills. I paint up to the edge I left at the bottom of my previous wash. I use negative painting to create the upper shape of trees and bushes by painting what is behind them—not the actual trees and bushes. I concentrate on creating a varied and interesting edge.

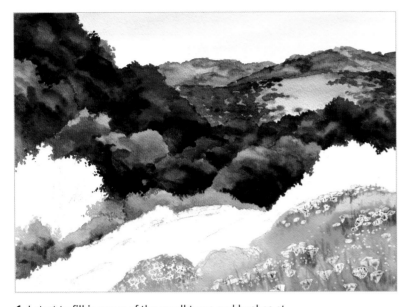

**Artist's Tip**

Negative painting is a key tool for the watercolorist because we don't work with opaque paints that hide what has been painted underneath. To create some edges we must first paint around an object, creating its shape by what we don't paint.

**6.** I start to fill in some of the small trees and bushes at the back edge of the foreground hills, using permanent yellow lemon, permanent yellow deep, permanent green #1, cerulean blue, and magenta. I'm using brighter colors because I want the hills to progressively become more colorful and appealing as they come forward in the scene. I wash in a colorful wash with my 1" flat brush over the closet hills at the bottom of my paper. While the wash is wet, I use a rigger brush to add soft detail to indicate some of the plant structure that will hold the colorful blossoms.

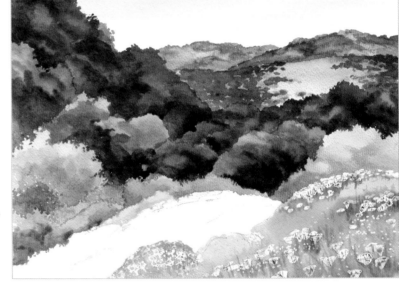

▶ **7.** I continue painting in the rest of the foliage between the foreground hills and the midground hills with my medium brush. I use the same color palette, but I focus on brighter colors and more detailed edges for these trees and bushes. Because they are closer, we should see more detail in them. I exaggerate and concentrate the colors to bring more attention to them.

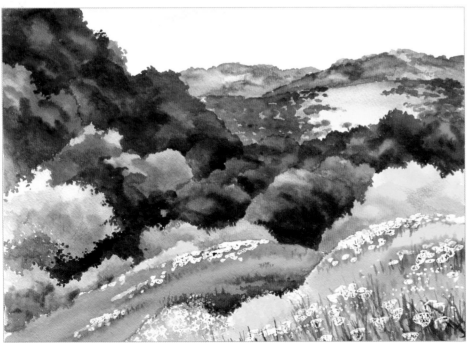

**8.** I wash in some color to the remaining foreground hills with my 1" flat brush, using Hooker's green, permanent green #1, permanent green #2, and permanent yellow lemon. While this wash is wet, I add a few vertical and diagonal strokes with a rigger brush to suggest stems and leaves. I scrape out a few marks with a palette knife to add some lighter marks to this area. Once dry, I use my rigger brush to add more detail to build up the mass of plant structure supporting the blossoms. The detail on dry paper contrasts nicely with the previous wet-into-wet brush strokes.

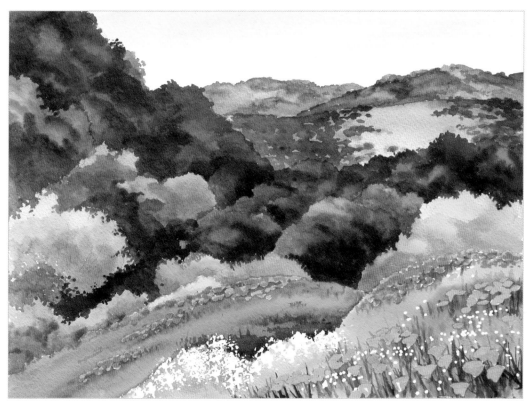

**9.** I remove the masking fluid from the wildflowers. Using varying parts of permanent yellow deep and permanent red, I mix up three puddles of orange tones for the poppies. I paint the lighter tone of yellow-orange on all the poppies, avoiding the small flowers that I want to keep white. Once dry, I come back in with the other two orange tones to create the shape of the poppies and add some detail. I paint a light wash of magenta over the cluster of blossoms in the lower middle of the painting.

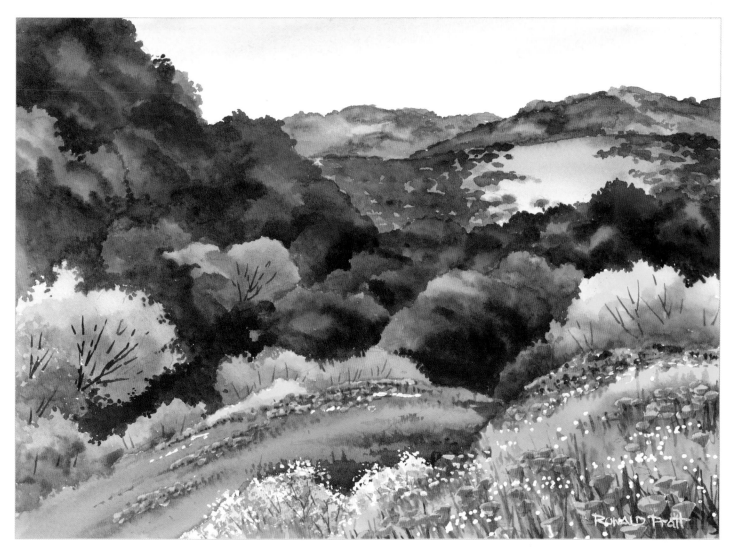

**10.** I add more detail to the poppies to make them look like clusters of bright orange flowers with some variety to them. I add branches and limbs to a few of the nearer trees and bushes, using a small detail brush. I add a little opera to some of the foreground blossoms for a spring-pink look. Lastly I add a few additional blossoms and details with white gouache for balance and interest.

# Painting Buildings

Whenever I see an old structure I try to take a photo of it right away. Too often I have waited, only to see that structure torn down suddenly to make way for another strip mall or high-density housing project. I frequently pass by this old barn, which has a character about it that I could not pass up as a painting subject. It's an alluring scene with the wild mustard field in the foreground, cherry trees in bloom, and foothills. For my painting I decide to lower the hills behind the barn and move the windmill behind it to create a more dynamic relationship.

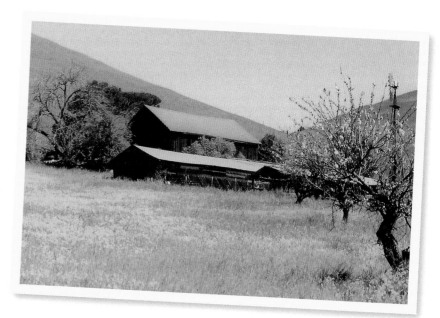

## Palette

burnt sienna, cerulean blue, Hooker's green, opera, permanent green #1, permanent green #2, permanent magenta, permanent red, permanent yellow deep, permanent yellow lemon, ultramarine blue, white gouache, yellow ochre

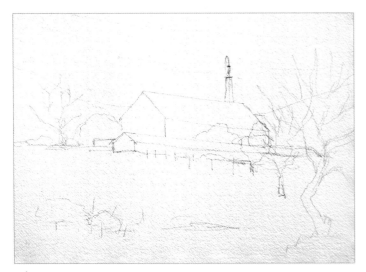

**1.** After completing a value sketch, I make a light pencil drawing directly on my watercolor paper. I focus on basic shapes and their location without worrying too much about detail. This looseness will allow for adjustments to be made as I see what develops on the paper. Remember: you never totally control watercolor paints, so a certain amount of flexibility helps create a stronger painting.

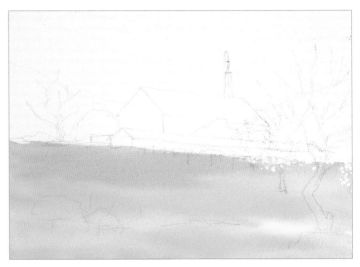

**2.** I want to save the white of my paper for the cherry blossoms in the three foreground trees on the right. I dampen and squeeze the excess water out of a small piece of natural sponge, and then I stamp in liquid mask in a pattern that duplicates the blossoms. I want the blossoms to appear smaller in the tree closest to the barn and larger in the tree in the foreground. Test your stamping technique on scrap paper first to get the right pattern and make sure you have the right amount of fluid. Once the masking is dry, I wet the paper in the mustard field and flood in a wash of permanent yellow lemon and permanent yellow deep.

**3.** Next I wet the sky area. Using a 1" flat brush and a wash of cobalt blue, cerulean blue, and opera, I flood in color that is a bit darker at the top of the sky and gets lighter and pinker as it approaches the crest of the hills. While this wash is wet—and before it has time to soak into the paper—I take a crumpled tissue and gently blot out some cloud shapes. Make sure to rotate your tissue so you don't pick up paint in one area and stamp it back into the paper in another area. Vary the size, spacing, and placement of your clouds. While the paper is still damp I use a medium round brush to put in some slightly darker bottoms on the clouds to give them form and dimension. I usually leave harder edges on the cloud bottoms, but I soften the tops of my brush strokes here with a damp brush so they have a soft, billowy look.

*Artist's Tip*

If your paper dries too quickly and you think there are too many hard edges in your clouds, you can soften a few edges by scrubbing with a stiff bristle brush or with a damp cotton swab.

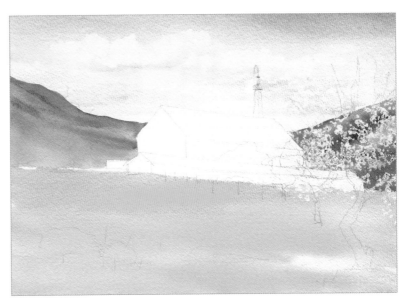

**4.** I paint in the background hills on either side of the barn structures with my 1" flat brush, using Hooker's green, permanent green #1 and #2, permanent yellow deep, and a little bit of burnt sienna. I indicate the slope of the hills with my brush strokes, using primarily diagonal strokes.

**5.** I start to stamp in some of the foliage for the wild mustard plants with a natural sea sponge and a variety of green colors. I make sure the scale of these plants gets continuously smaller as the field recedes to create a sense of depth. Toward the back of the field, near the farm structures, I put in a few horizontal dry brush strokes with my medium round brush to indicate green foliage. Then I start working on the distant trees that surround and frame the barns, using a small round brush and Hooker's green, permanent green #1, burnt sienna, yellow ochre, and permanent yellow lemon.

**6.** I wet the roof of the barn with my ½" flat brush and clean water, staying away from the edge so the surrounding color doesn't begin to bleed. Then I start to lay in a graded wash that is darker toward the top and right, using burnt sienna, magenta, and burnt sienna mixed with ultramarine blue. With color in my brush I can go right up to the edge of previously painted areas to create a clean intersection. I paint the roof on the lower structure in the same manner, with a gradation that gets slightly darker as it goes to the right. I use more blue to differentiate the two roofs. Once dry, I paint the side of the larger barn. Starting at the right, I chase a wet edge across the side, using vertical brush strokes to indicate wooden boards. I paint carefully around the shapes of the trees between the two buildings. I paint the side of the lower building the same way, using a dark value brown and blue-brown. At the bottom of this wall I negatively paint around some of the bushes and fence posts. Then I paint the small storage building to the left with burnt sienna.

**7.** I paint the fronts of the buildings with a darker mixture of burnt sienna and ultramarine blue. I vary these surfaces with color and value and hint at some of the detail by lifting out some color with a damp brush. Once dry, I add detail with a small round brush, including doors, window openings, fence posts, and gaps in the wood siding. A few dry brush strokes following the direction of the roof slopes give them an old, weathered look. I add a bit of detail to the small storage shed.

**8.** I start to stamp in the wild mustard plants, using my sea sponge and permanent yellow lemon and permanent yellow deep. Again, I want the scale to get progressively smaller as the field recedes in the distance. The sponge works great for putting down large areas of texture, but I use a small round brush for control to fine-tune certain areas, especially farther back in the field. Next I use my rigger brush and a dark mixture of burnt sienna and ultramarine blue to paint the trunks and branches of the cherry trees. I start at the bottom of each tree and work my way up. Notice how the branches get smaller as they split off, until there are just wispy branches at the outer edges. I also paint the lone tree to the left of the barns.

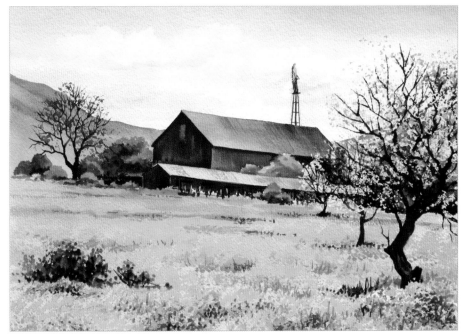

**9.** I stamp in some pink blossoms in the cherry trees with my sea sponge, using opera and magenta. The original masking fluid is still on the paper, so this will be the background color for the blossoms when the mask is removed. I paint the windmill behind the barns with a small round brush. I add a little foliage to the bare tree on the left of the barns, using burnt sienna and a small sea sponge. I also paint in a couple of bushes in the lower left foreground.

**10.** I remove the masking fluid with masking fluid pickup. Then I stamp over the revealed white paper with my sea sponge and more pink. I stipple with the small round brush to break up any clumps left by the mask in the blossom areas. I also add a little magenta in the shadow areas of the trees. I add a few more branches to the cherry trees and a little more detail to the barn structures. Then I add a few highlights to the barns and surrounding areas with white gouache. Lastly I add a soaring bird in the sky to add some life to the scene.

# Depicting Water

Although this photo of a gently cascading stream in the Sierra Foothills is a wonderful scene and a strong composition, I still want to change some things to make it an even stronger statement of the mood of the location. I decide to add additional foliage in the lower right foreground and simplify the foliage in the background. I also want to add some brighter foliage hanging over the water from the left to better frame the scene.

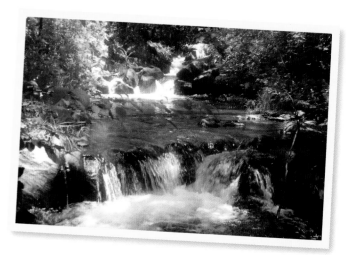

## Palette

burnt sienna, cerulean blue, Holbien's ultramarine blue, Hooker's green, permanent green #1, permanent green #2, permanent magenta, permanent yellow deep, permanent yellow lemon, white gouache, yellow ochre

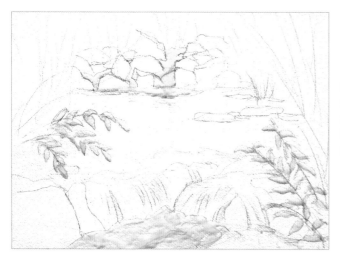

**1.** After making a quick value sketch I do a line drawing of the scene on my watercolor paper with a #2 pencil. I focus on the basic arrangement of shapes within the scene and very minimal details, except in the areas that I am going to mask out. Then I paint masking fluid over the light waterfall areas, reflections in the calm water, sunlit foliage, and the foamy water at the bottom.

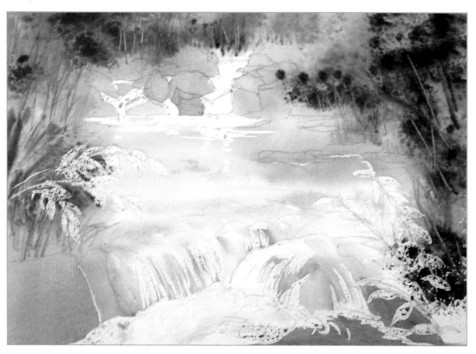

**2.** Once the masking fluid is dry, I wet the entire painting with my 1" flat brush, using clean water. Then I start to wash in background colors on the wet paper. I loosely brush various greens and yellows into foliage areas; yellow ochre, burnt sienna, and magenta in the general rock areas; and ultramarine blue and cerulean blue into the dark areas of the foreground waterfalls. Don't worry if some of your colors run into other areas—the overlapping colors will add variety and keep the painting from being too tight. I stamp in some foliage texture with my sea sponges and add some branches with the rigger brush.

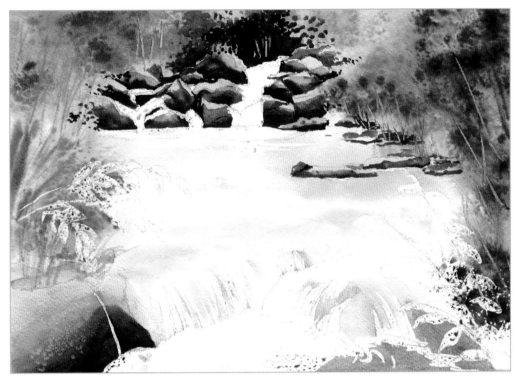

**3.** With my medium and small round brushes I start working on the background rocks along the waterfall, as well as the rocks to the right of the calm water. I want these to be fairly dark in value to contrast against the light water. Using yellow ochre, burnt sienna, and burnt sienna mixed with ultramarine blue for my dark brown, I paint the rocks. I keep them lighter at the top and make them darker near the bottom to make them three-dimensional. I also start to paint the larger rocks in the lower left corner. Then I use my medium round brush to start painting the deep shadowed areas in the foliage behind the background waterfall. Using a mixture of Hooker's green and ultramarine blue for a dark green color, I paint in this area and stipple with the tip of the brush at the edges to create foliage texture.

*Artist's Tip*

Starting with a colorful wet-into-wet wash accomplishes two things: it establishes good, rich color in the background without focusing on detail too early, and it creates a unifying underpainting to tie different parts of your painting together.

**4.** I paint calm water between the waterfalls with yellow ochre and burnt sienna, using horizontal strokes with my ½" flat brush. The light areas will indicate the shallowness of this clear, calm water and the sandy bottom, while the darker areas will show the reflection of the darker rock areas behind. With magenta, dark brown, and ultramarine blue, I add the dark shadow areas on the lower right side of the painting and let these darks run into the dark areas of the foreground waterfall.

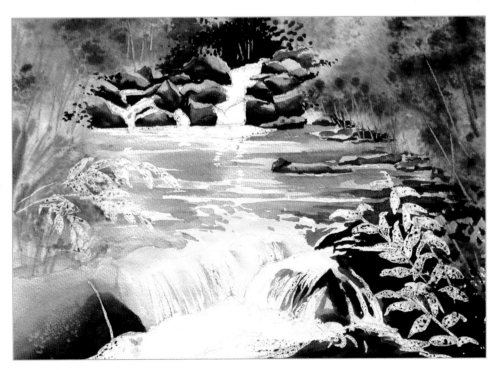

**5.** Now I concentrate on the foliage surrounding the stream. Using my damp sea sponges, I pick up color from the palette and stamp in foliage, making sure to leave brighter yellow and green areas for contrast against darker areas of shadowed foliage. I use a smaller textured sponge in the background foliage and a larger sponge in the foreground to create a change in scale from front to back. I also stipple with medium and small brushes to help create better edges in the foliage. Then I use a rigger brush to add branches, trunks, and other structure to the vegetation.

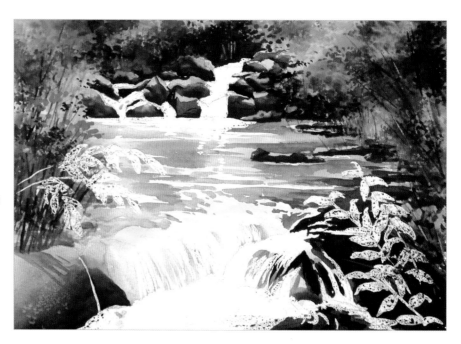

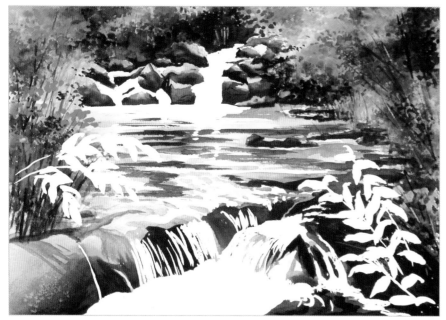

**6.** I add a few horizontal dark brown brush strokes to the calm water, using a ½" flat brush. Then I paint the dark foreground rocks with dark brown, magenta, and ultramarine. These rocks are underwater, so their shapes are more vague than the rocks above the water. Their dark values set off the light of the water, creating a nice waterfall effect. When these areas are dry I pull off the mask, using a masking fluid pickup or soft towel.

**7.** Using my medium brush I paint the foreground foliage, keeping the value light to indicate that this vegetation is drenched in sunlight. I use permanent yellow lemon, permanent green #1, permanent green #2, and Hooker's green for variety and interest. I paint the water above the foreground waterfall, using cerulean blue to indicate it is just starting to drop over the rocks. This change of angle reflects the color of the sky, even though the sky is not visible in the scene. I also add some cerulean blue to water areas that are in shadow, as well as into the foamy, turbulent water in the foreground.

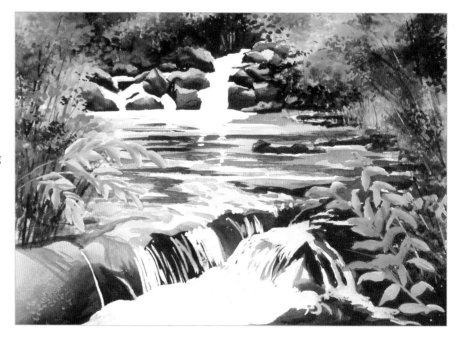

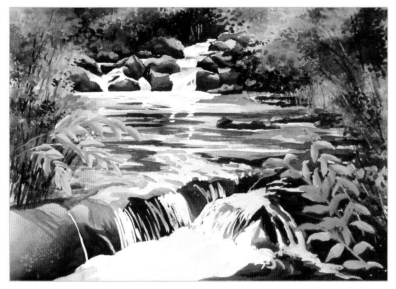

**8.** Keeping the background waterfall mostly light in value, I add a little bit of shadowing with cerulean blue to show the cascading effect as the water tumbles over the rocks and boulders. I also add a few horizontal brush strokes in the light area just below the falls, which hints that the water is becoming calm in this area of the stream.

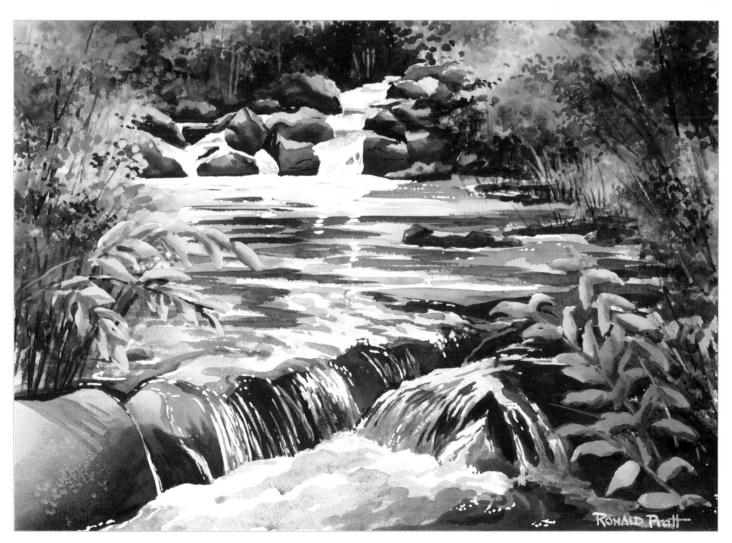

**9.** Using a mixture of cerulean blue and magenta, I start to paint the detail of the foreground waterfall, using my small round brush. Carefully observing my reference photo, I try to duplicate the patterns of light and dark that are created by the water as it falls over the rocks. I carefully add brush strokes in the direction the water is flowing. Then I darken some areas to indicate shadows. Lastly I adjust edges and use a bit of white gouache to add some sparkle to the water in a few places.

# Evoking Mood

There are a variety of reasons why I may choose a subject to paint. Sometimes it is the relationship of shapes that intrigues me, or the mood of a scene. Sometimes, as in this case, I want to paint a subject because of the colors. I've always been fascinated with the wonderful colors in the spring in the foothills of California. Although some of the colors are washed out in my photo, I still remember the vast array of brilliant colors in this scene. It was the mood that the colors created that made me want to paint what I saw.

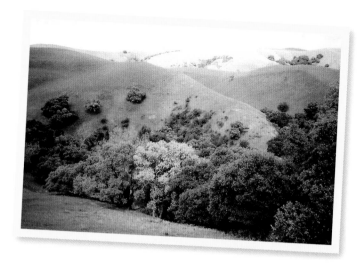

## Palette

burnt sienna, cerulean blue, cobalt blue, Hooker's green, opera, permanent green #1, permanent green #2, permanent magenta, permanent red, permanent yellow deep, permanent yellow lemon, ultramarine blue, white gouache, yellow ochre

**1.** After creating a quick value sketch, I do my line drawing on 300-lb. watercolor paper. Then I mask out some of the trees in bloom, using a small nylon brush coated with a thin layer of soap. I completely mask the mostly white blossoming tree in the center, and I mask bits and pieces of pink and magenta trees tucked among the others in the foreground. I also mask wildflowers in the foreground, using larger shapes for the closer flowers on the right and small clusters for the flowers farther away in the grassy area on the left.

**2.** After wetting the sheet of paper, I flood cobalt blue and cerulean blue in the sky area. I wash my greens, browns, yellows, pinks, and magentas in the hills and tree areas. I am conscious of what I will paint in each area and try to paint with appropriate colors, but I remind myself that the reason for the colorful wash is to add a bit of randomness to the painting. I don't want to "over control" this step.

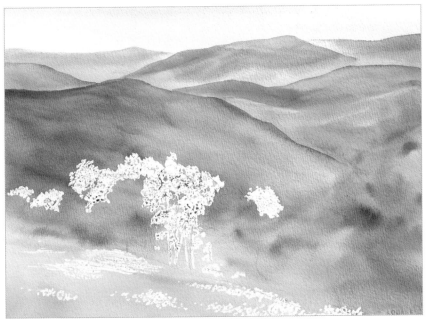

**3.** Now I start separating the colorful wash in the background into separate hills. I can create a hard edge at the top of each hill by using a graded wash on dry paper. I use a 1" flat brush and the same general colors from my first wash. I work on one hill at a time, allowing each to dry before moving on to the next. I keep the hills farthest away the lightest in value and palest in color tone. This pushes them back in the scene and creates a greater sense of depth. For the closer hills I create a stronger edge by using a bit more color. After pulling my brush along the ridgeline, I begin to dilute the pigment in the brush and fade that wash out with clean water.

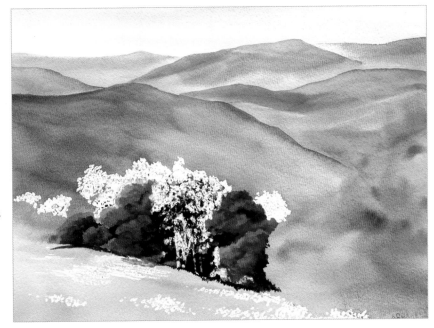

**4.** Starting at the center of interest—the blooming foreground tree—I begin painting the trees. I use a medium round brush and Hooker's green, permanent green #1, permanent green #2, permanent yellow lemon, and cerulean blue to paint in tree shapes. The light source is from the upper left, so the left side and tops of the trees will be lighter and brighter and get progressively darker in value and color toward the bottoms and right side. I tuck in trees behind each other to create the mass of trees, creating the illusion of depth. At the bottom of this area I create a nice edge between the trees and the foreground meadow.

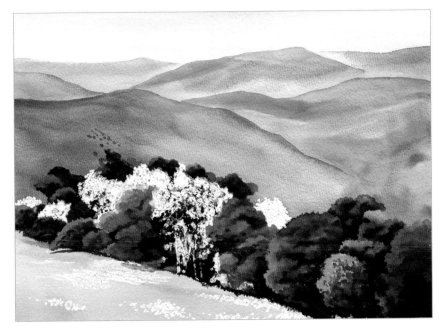

**5.** I continue painting the trees, moving from left to right, away from my center of interest. I want these trees to be fairly dark in value but varied in color, so I introduce burnt sienna, magenta, and cerulean blue in the mix of colors for variety. I work on dry paper and use colors that are not too diluted so I get strong tone. Remember that the bottom edge of a tree will become the top edge of the next tree. Use negative painting to create that top edge as you reach that point in the tree you are working on. To create a somewhat mottled appearance, I stipple a bit with my brush, mimicking the cluster of foliage.

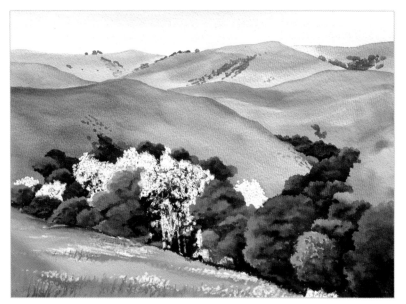

**6.** I add more trees behind the initial foreground trees, making smaller clusters of foliage behind them. I also start to paint the cluster of trees growing up the canyon on the right side. I make the tree shapes progressively smaller as they recede and eventually disappear between the hills. Using my small round brush, I start indicating some of the distant tree and bush clusters on the farthest hills. I keep these small and cooler in color to show their distance in the scene. I also use these to help better define some of the ridges and to show the wonderful patterns the plant life makes on the hills. With my ½" flat brush I wash in a variety of color and drybrush texture into the foreground meadow. Then I use a rigger brush to create some of the grassy texture.

**7.** Immediately behind the foreground trees are patterns of plant cover growing up the hill in random finger shapes. I paint these clusters with a medium round brush and the same colors I used for the trees. I paint them slightly lighter in value than the foreground trees to show the bushes tucking in behind the trees, and I break up the patterns into individual bushes at the top.

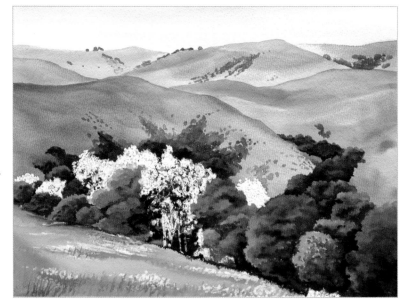

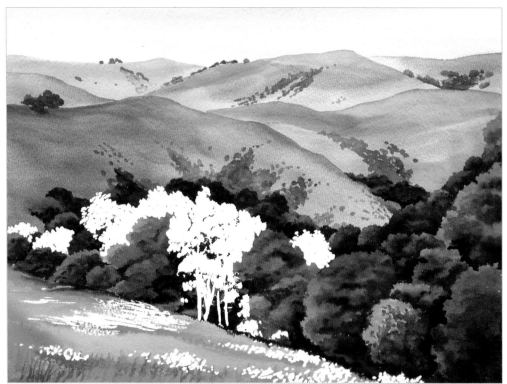

**8.** I finish painting the rest of the foreground trees that make up the taller cluster on the right side, using my medium brush and the same tree colors. By making the trees here a different size cluster, I vary the shapes in the painting to avoid boredom and add variety. When the trees are done I dry the entire painting with a hair dryer. Then I remove the masking fluid.

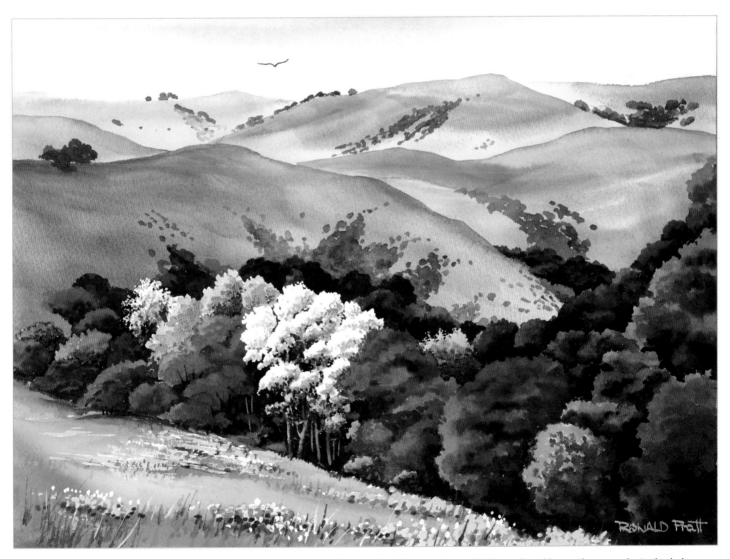

**9.** I start painting the blooming trees with a small round brush. For the mostly white tree, I use a light cerulean blue and green mix. I stipple in a darker mix toward the right and the bottom of the blossom clusters to show shape. Using the darker colors around this tree and my small brush, I break up some of the irregular shapes left by the mask. I want the edges of this tree to be a little more defined than the other trees because it is the center of interest. I repeat the process, using pink and magenta, for the other tree blossoms. For the wildflowers in the foreground, I use permanent yellow lemon, pink, and magenta for a nice splash of color. I also use a little bit of white gouache to add a few random white flowers and lighter blades of grass. I add a few tree trunks and branches in the center of interest and a couple of trees at the top left of the midground hill to keep the viewer's eye from running along this ridgeline and off the page. To complete the scene, I add a bird soaring above the hills.

# Capturing Reflections

When I travel I always carry a small digital camera that fits in my pocket and is readily available if I see a potential painting subject. Often, I come across a scene that might work but would be even more dramatic a few weeks later, or several weeks past. I still take the photo because I can use my artistic license and imagine what it would like at another time. I took this photo of the swans, knowing that it would have been much more colorful in a couple weeks when the fall colors in Michigan really started to turn. I liked the serenity of this scene with the swans gracefully swimming at the edge of the tree-lined lake, enjoying a calm day before the onset of winter. Although this particular location hadn't turned the brilliant fall colors I had seen elsewhere, I decide to paint it in fall colors anyway.

## Palette

burnt sienna, Hooker's green, opera, permanent green #1, permanent orange, permanent red, permanent yellow deep, permanent yellow lemon, thalo blue, ultramarine blue, white gouache, yellow ochre

**1.** After completing a value sketch, I do a light line drawing on my paper to locate these main components and to further study the design. I choose to simplify the flock of swans and only put in three. After carefully drawing the swans, I use liquid mask to cover them until the end of the painting.

**2.** I mix a light puddle of thalo blue and a small puddle of opera. After wetting the paper completely, I paint a graded wash starting at the top. I pull down a bit of the thalo blue, keeping it darker at the top and getting lighter as I move down the page. I mix in a little opera as it approaches the tree line. With a crumpled tissue, I blot out a few clouds. On the bottom of my paper I make a mirror image wash of the sky on the water area. The wash should start light and grow stronger as it nears the bottom of the paper.

**3.** I use all the colors in my palette to create the colorful fall foliage. I am left-handed and chase a wet edge from right to left across the paper. If you are right-handed, you might prefer to work from left to right. Work on dry paper so you can define the edges of your foliage. I use a ¹/2" flat brush to form a foundation at the lake edge and a natural sea sponge to create leafy texture at the tops of the trees. As I chase the wet edge across the page, I analyze the pattern of trees being created for interest, balance, color, and randomness. Don't go back into any area that is starting to dry as this will muddy the colors.

**4.** Once the colorful wash is completely dry, I separate the low plants and reeds at the bottom of the foliage. Using a medium round brush, I drop in stronger and darker colors at the top of this section, using negative painting around the reeds to shape them. I stipple and vary the edge up and down to form an interesting edge. With the ¹/2" flat brush and a small amount of water, I feather the wet, stippled paint up into my first colorful wash. When stippling, be careful to place analogous colors on top of existing colors to avoid muddiness. I create additional detail and shadows at the bottom edge where the reeds meet the water for interest and definition.

**5.** Next I add definition to the trees. I pick certain areas suggested by the colorful wash and create bits and pieces of tree edges. In addition to painting actual edges, I add stronger color around the tree edges, leaving the existing color in place, to create dimension. Remember that this is a cluster of trees and you are only painting parts of trees rather than perfect rows. Once I have an interesting cluster of trees, I add a few trunks and branches using a rigger brush.

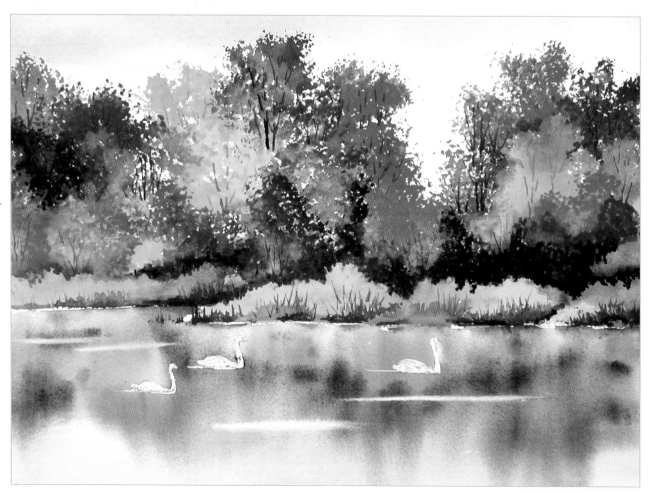

**6.** I make sure all my tree color paints are wet on my palette so I can work quickly in this step. With a flat brush, I wet the entire water area of the painting. Then, with the ½" flat brush, I pick up colors from my palette and place them in the water area below those same colors in the trees. I keep these colors close to the shore. The colors do not need to exactly match to the trees above, but should be close. Once the color is applied, I take a damp 1" flat synthetic bristle brush with no paint in it and pull a vertical stroke from the shoreline down to the bottom of the page. I repeat the process several times, and then clean the brush, squeeze the moisture out with a tissue, and keep repeating until I have a soft, slightly blurred reflection across the entire lake. While the water is wet, I lift a few horizontal strokes out with a clean, damp synthetic bristle brush to create soft ripples in the water.

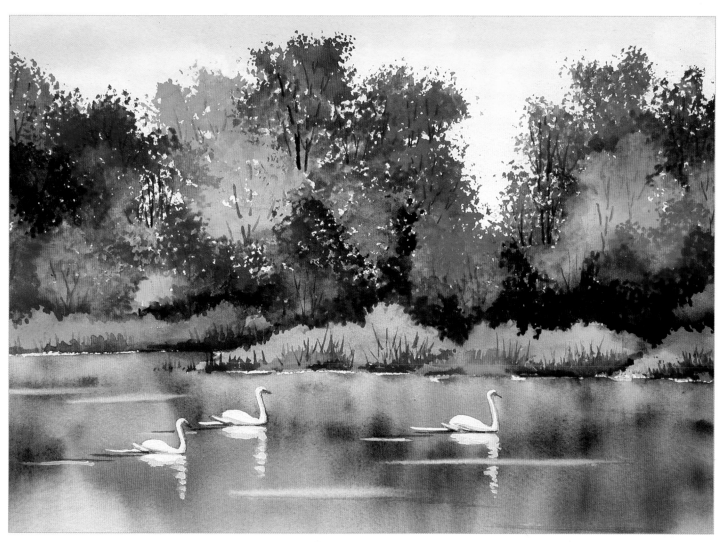

**7.** Once the lake is dry, I remove the mask from the swans and paint them. With a small detail brush, I paint a little shadowing on their necks and lower bodies. I paint the beaks and eyes, as well as stronger shading where the swans meet the water to make them appear to be swimming. The swans are white and should remain a light value so they stand out from the color in the water. If you did a good masking job initially, very little detail is needed. I add swan reflections with white gouache. The final painting shows a colorful and reflective autumn scene that is warm and inviting and has a much stronger mood than my original reference photo. Use your reference photos as a starting point and feel free to run with it. Create your dream autumn scene, and let the creative artist in you come out!

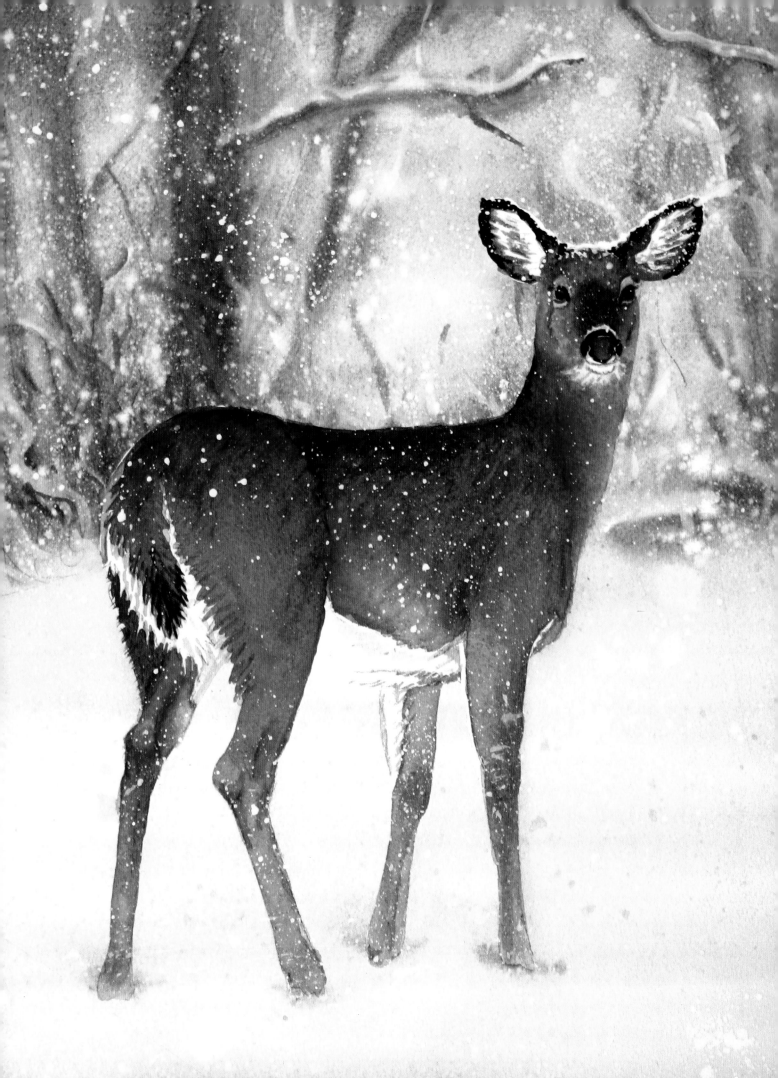

# CHAPTER 4

## Animals

### with Deb Watson

Animals enrich our lives in so many ways—whether they're beloved pets or majestic wildlife. Being able to capture their beauty in a painting is like bottling that warm, fuzzy feeling they give you so you can enjoy it again and again. The secret to capturing the essence of any animal is in the eyes. With an accurate outline of form and captivating eyes, a little more paint is all you need to suggest shape or background. Watercolor paints are perfect for suggesting believable backgrounds without much work. We can work wet-into-wet to create soft edges, use salt for texture, and implement masking to save key areas so that we're free to let the color flow. Every watercolor painting is unique. Yours may not be like mine, but it will be beautiful in a different way—so don't try to change a thing! Just cherish it for the beautiful painting it is.

# Blue Jay

The bright blue of this blue jay and the contrasting soft pink flowers drew me to this photo. To create a nice composition out of any photo, keep the parts you like and eliminate anything that distracts from those parts. Then organize what you have left. I use three transparent, pure primary colors in this project, from which you can mix all the other colors you'll need.

## *Palette*

aureolin yellow, permanent rose, thalo blue

**1.** I like to start my drawing on tracing paper so I can organize and erase without damaging my watercolor paper. I want the blue jay to be the center of interest and the flowering branches to support him, not distract, so I decide to eliminate some of the flowers. I organize the flowers I keep so the top of the flowers on the upper branch forms a line parallel to the limb. This leads my viewer's eye right to the bird and down the curve of his back to the lower branch. The curve of the lower branch takes you back to the upper branch. This creates a circular composition and also divides the background (negative space) into three main shapes, which is visually pleasing.

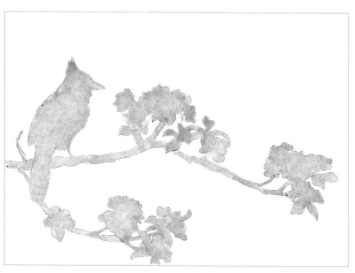

**2.** Now that my composition is worked out, I use graphite paper to transfer the outline of my drawing to my watercolor paper. I only draw the outline and not the details, because the next step is to paint that outline with liquid mask to protect the areas I want to keep. I paint the masking as carefully as I would paint the object with real paint, using an old brush. While the masking dries, I mix a light green (more yellow, less blue) and a very dark green (more blue, very little yellow) and use a tiny bit of permanent rose in each to tone them down.

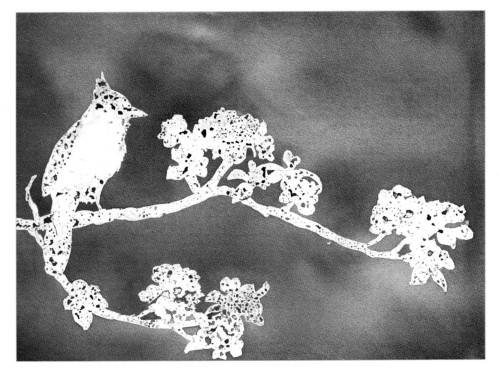

*Artist's Tip*

Mix more paint than you think you'll need, using a lot of fresh paint from the tube and just a little water so the washes are the consistency of cream.

**3.** I wet the board with my hake brush, tilting it so the excess water runs off. Then I squeeze the water out of my brush before loading it with the light green. Working on a wet surface will help the paint blend smoothly, but it also dilutes the colors, so I try not to add more water with a wet brush. I put the light green down on the wet board in two strokes. Work with as light a touch as you can, just laying the paint down without brushing it deeply into the paper. Then I squeeze the moisture out of my brush again, load it with dark green mix, and fill in the rest. I tilt the board gently to mix and let it dry. Let the paint mix on its own; too many brushstrokes spoils the wash. If your wash starts to dry unevenly, you can mist it a bit with the misting bottle to add a touch of water.

*Artist's Tip*

Having your colors premixed, ready to go, and using a big brush will help in creating a smooth wash. If puddles form at the edge of or on your painting, wick them up with a paper towel to prevent them from flowing back into your drying wash.

**4.** My first wash dries lighter than I want, which is usual. To get rich deep colors in a smooth wash, you may need to paint it several times, letting it dry completely between layers. To give mine a second coat, I mist the board lightly and paint a second wash the exact same way as the first. This wash dries with plenty of color. There isn't as much value change as my photo, but I don't want the background to detract from subject, so it's perfect. Once the wash is completely dry, I carefully rub off the masking, revealing the white paper.

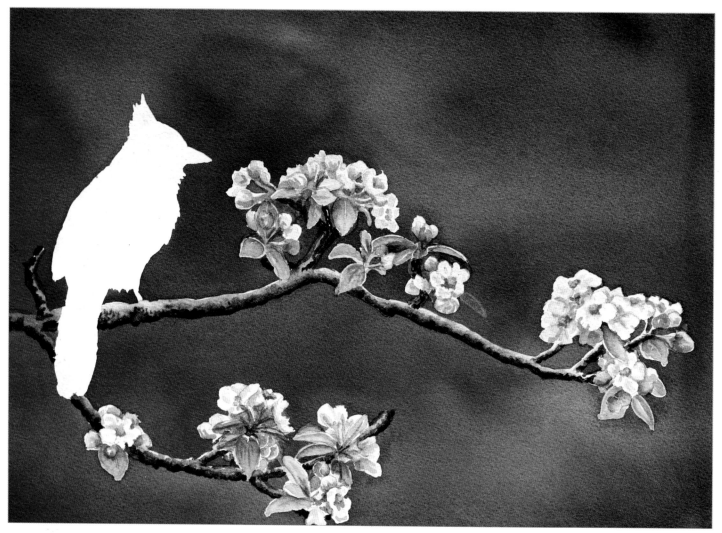

**5.** I use pure permanent rose for the buds and a hint of the color for the petals, leaving some white areas for sparkle. I paint on dry paper, laying down the darkest spot of pink color and adding water, letting the color spread on its own. I paint the centers of the petals yellow. To add shadows to the centers, I mix yellow with a bit of pink and the lighter green for a dark gold. For the green leaves, I mix blue and yellow for a purer shade that will stand out from the background, leaving a thin edge of white around the edges. I mix dark green and pink for the dark branches. I want the top of most of the branches to be almost white and the bottom to be black. Such a big value change is hard when working wet-into-wet, so I do it in layers. I paint the black on the bottom of the branch and let it dry. Then I mix a brown with yellow, red, and a touch of dark green. Leaving a thin line of white at the top, I paint the brown over the branch, including the dark area, rubbing the edge of the dark just a bit so it blends into the brown.

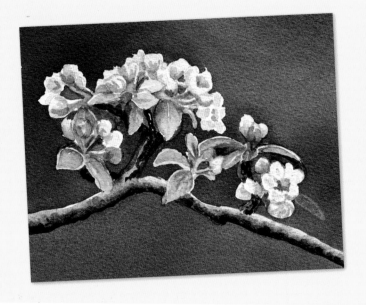

Note the variety of color and value, from the white highlights to the deep shadows, that gives these buds a three-dimensional feel. I follow the photograph of the flowers closely, working on one small section at a time for a realistic look.

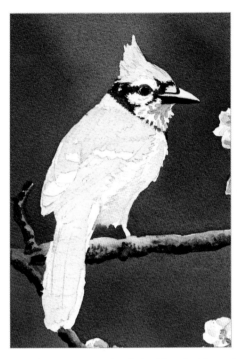

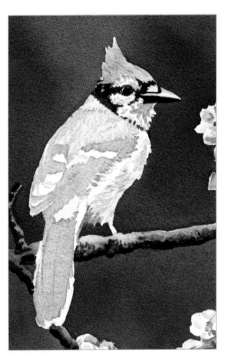

**6.** Moving to the blue jay, I trace in all the bits of white—the top of the beak, around the eyes, the neck, the chest, and the white in the feather pattern. I paint everything else a very light blue, using a touch of thalo blue and lots of water. When the blue is dry, I put in the black on his head and bottom of the beak. Next I mix my gold mix from step 5 with a touch of light blue to make a warm gray for the first shadow layer in the white areas.

**7.** Next I paint the darker blue areas, using short strokes for the shorter feathers and pulling the blue behind the white of the chest feathers. Once the blues are dark enough, I draw in the dark strips on the longer feathers without trying to copy the pattern exactly.

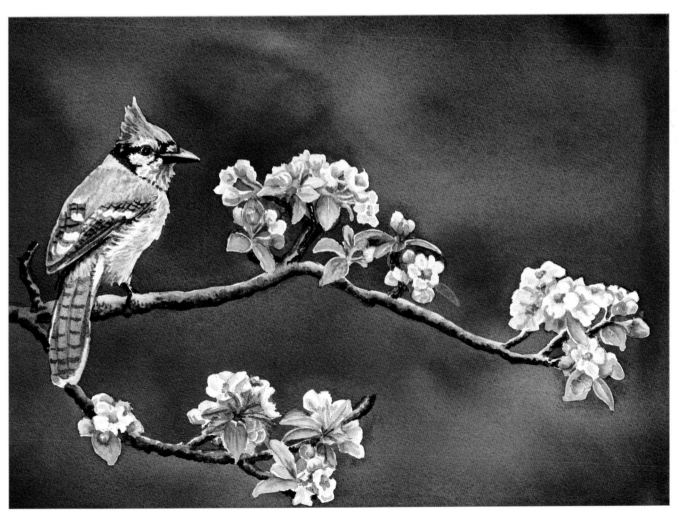

**8.** I add the bird's black foot. Then I wash over the feathers again with more dark blue and paint in lines to suggest pattern.

# Bunny

With watercolor, I can make even a complex subject easy to paint by organizing it into layers—a glowing background and the foreground bunny, the star of the painting. Using big washes and salt creates a field of flowers in sunshine. Moving from a light value at the top to a darker value at the bottom helps stabilize the composition and makes the bunny pop forward. Using masking in layers, I can work quickly and fearlessly on each area, getting glowing colors and precise results.

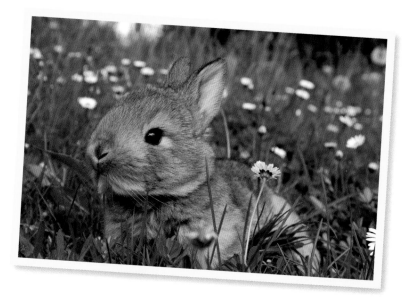

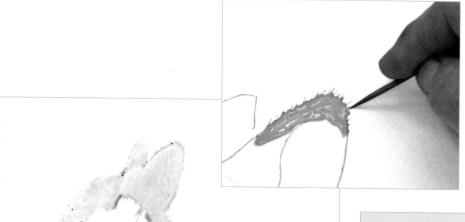

## Palette
aureolin yellow,
permanent rose, thalo blue

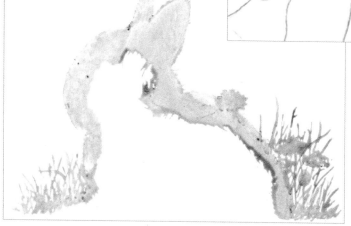

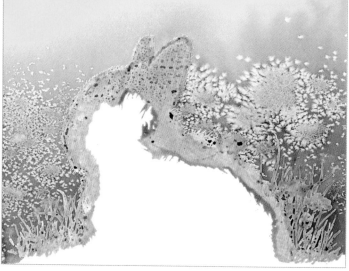

**1.** I use graphite paper to trace the outline of the bunny onto my watercolor paper. I draw a few blades of grass on either side of the bunny, tapering the height of the grass down on both sides. I draw a few oval flower shapes in the grass. Then I use masking fluid to carefully paint my drawing. Starting with the bunny, I apply the mask with an old brush. While the mask is still wet, I use a toothpick to pull out fine hairs, being careful not to scratch the paper. I don't mask the entire bunny because the blocked-out edge is enough to prevent the wash from running onto the bunny. When the bunny edges are done, I paint each blade of grass and flower shape with masking.

**2.** I use yellow and blue paint to make puddles of yellow, light green, and dark green. I place a book under the top of my paper to tilt it about 30 degrees. With my hake brush, I paint the entire background area yellow and wipe excess paint with a paper towel so it doesn't drip. While the yellow is still wet, I start painting about a third the way down with light green on either side of the bunny and down to the masked grass area. If the wash starts to dry, I spray it with my misting bottle to keep it slightly damp. Next I paint dark green on the bottom third. The wet paints blend softly. When it's just dry enough that the shine is gone from the surface, I sprinkle table salt over the green area of the wash.

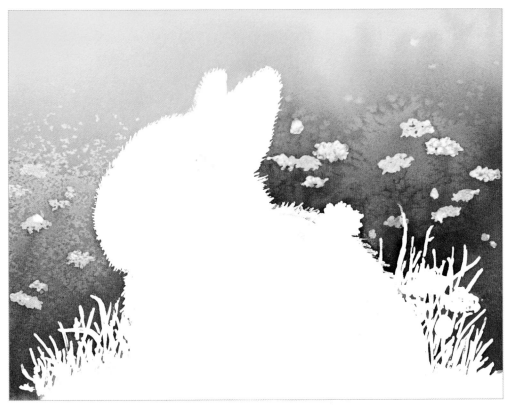

**3.** When the first wash is dry, I brush off the excess salt to reveal a wild pattern that will make great background daisies. I draw some oval flower shapes in the background and paint them with mask. I mix up more puddles of yellow, light green, and dark green. I want my new dark green even darker, so I use less yellow, more blue, and a bit of red. I repeat the washes from step 2. This time I don't use salt, although you can if you like more texture. My second wash dries nicely; the salt texture is toned down and the colors are well saturated. I peel off all the masking. The flower shapes I masked over the first salted wash now look white compared to the darker second wash, and they have built-in texture.

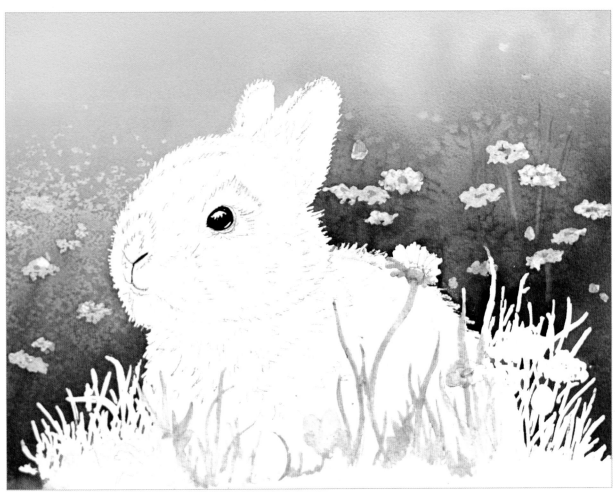

**4.** To finish the background, I put yellow centers in the daisies. Then I lift out stems on a few of the flowers by painting the stem area with clean water and dabbing it with a paper towel to pick up the paint. The background is done, and it is time for the main subject. I draw the bunny's fur, paying close attention to its length and direction, carefully noting the light and dark areas. Bunny fur is typically lighter around the nose, eyes, and jaw, and darker on top of the nose and ear edges. I like to paint the eye first, with black mixed from my darkest green plus red. Then I draw the grass in front of the bunny with a lot of variety in shape and size and paint it with mask.

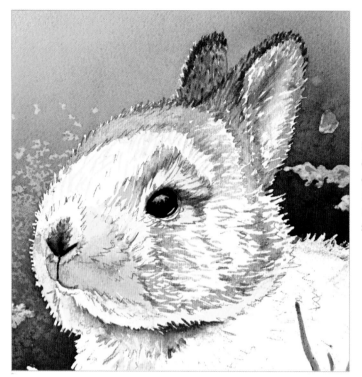

**5.** I mix red and yellow for puddles of orange, and then I add my other colors (light green, dark green, and blue) to the orange to create many different brown shades. I start with watery washes of brown shades, laying solid color over areas that don't have much fur texture, like the muzzle. For areas where the fur is longer or more variegated, I apply short strokes of color with the tip of my brush.

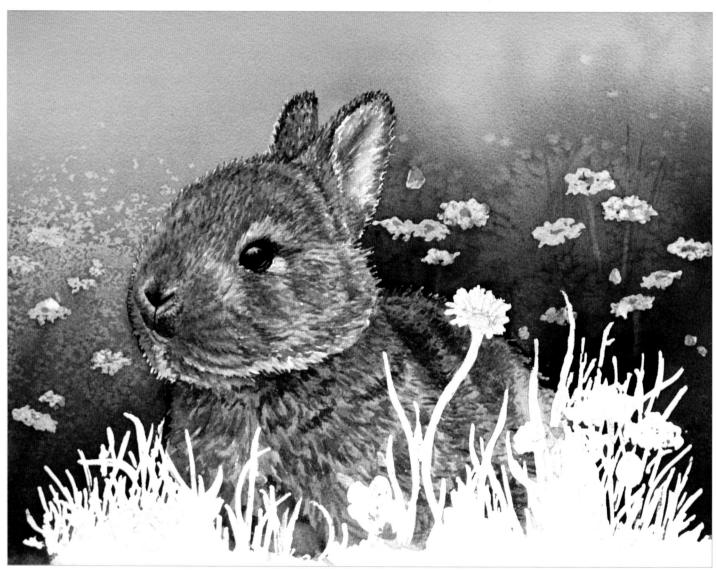

**6.** After the first layers are dry, I repeat, adding more strokes on top to darken, outline, or add a mottled texture. I use three or four washes on the darkest areas and leave the light areas barely touched. On the body of the bunny, I use more smooth washes with fewer fur strokes toward the back. Then I peel off the last of the masking.

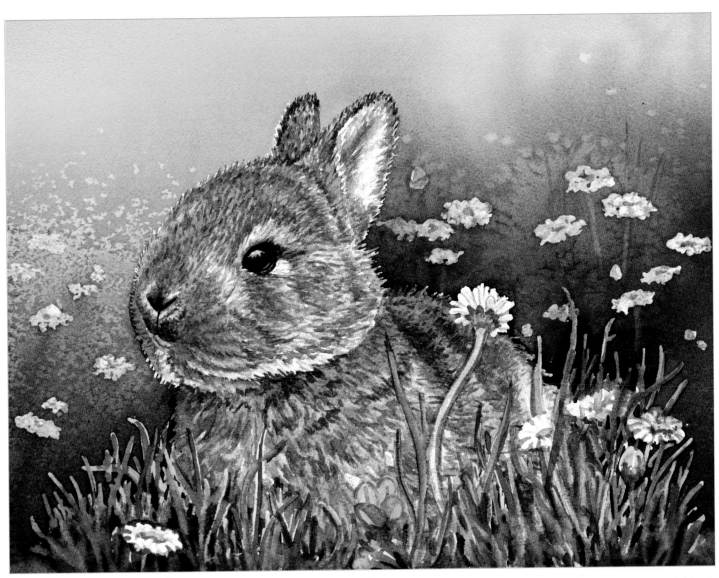

**7.** Leaving the flowers and stems white, I paint the grass area light green. While still damp, I paint some blades a medium green, letting it blend softly. I paint in some dark spaces between the grass blades, using triangle or oblong shapes. When the grass is dry, I paint the flower centers and details, making the stems a reddish brown and outlining some petals. I put some grass over a few of the flowers. By layering paint and masking, I let the watercolor produce great results in a fun way. This is a happy bunny.

# Deer In Snow

Anyone can paint softly falling snow with a toothbrush and wet-into-wet watercolor. Deer and woods are also easy, when done with a limited palette and in a step-by-step fashion. By leaving the background soft and fuzzy, the deer stands out for the most visual impact. More impact and minimal work? No wonder snow scenes are a favorite of painters everywhere!

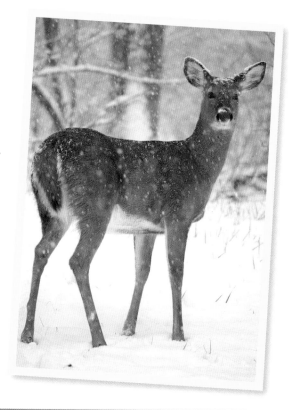

### Palette
burnt sienna, cerulean blue, opaque white,
raw sienna, ultramarine blue

**1.** I use graphite paper to trace just the outline of the deer from my photograph onto my watercolor paper. Behind the deer I draw background trees in the upper third of the picture—an odd number of trees grouped on the left and a smaller grouping on the right. I leave a clearing in the middle to add more sense of space. I draw these darkly so I'll be able to see them under my first wash. I vary the tree width, making some fat and some thin. With an old brush, I paint masking fluid over the entire deer. The masking fluid will preserve the white paper while I paint the landscape around it wet-into-wet.

**2.** I mix burnt sienna and ultramarine blue for the gray tree color, and I mix cerulean blue with a small bit of this gray mix for the background. I wet my paper with clean water and wipe off any puddles. I paint the cerulean mix on the top third by dabbing it on, leaving unpainted space here and there. I also paint a stripe of cerulean on the very bottom of the paper. I clean most of the paint out of my brush and paint back and forth horizontally over the bottom two-thirds to smooth out the layers. With a small brush, I add cerulean mix at the bottom of each of the deer's legs.

112

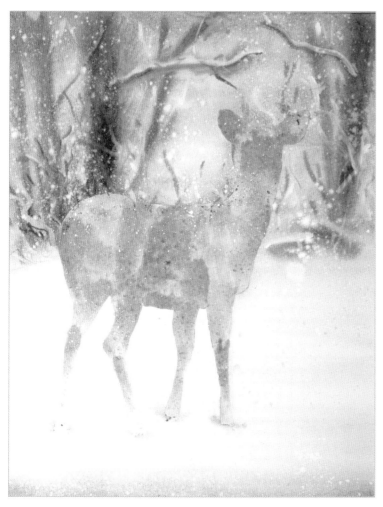

**3.** While the paper starts to dry, I paint a tree with the gray mix to test the dampness. If it spreads out too much, I let it dry a bit longer. When the tree just spreads a little, I paint all the trees. I add lots of branches to the trees, overlapping the trunks for a realistic look. I use white paint to add snow on top of some of the branches and draw on a few white branches. Then I use a damp toothbrush to spatter on white paint. I dip the top end of the damp toothbrush in the white paint and tap it on my paper towel to wick off excess liquid. Then I draw my thumb across the bristles to spatter.

**4.** When the paper is dry I remove the masking on the deer and trace the deer's details. The eyes and face are especially important and deserve close attention. I shade the darkest areas with my pencil.

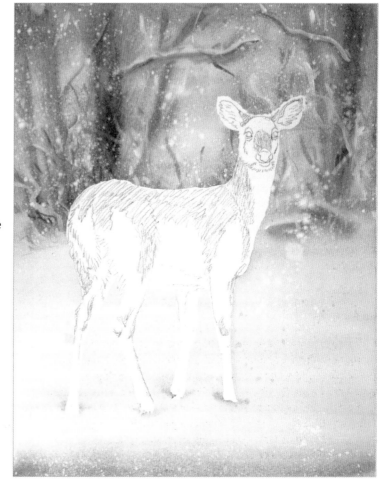

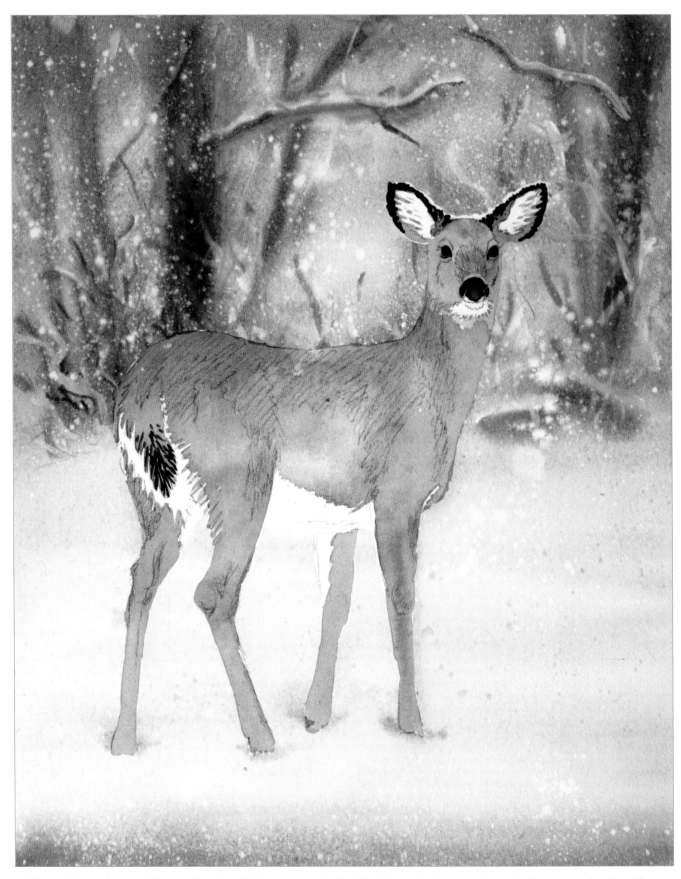

**5.** Then I mix raw sienna and burnt sienna in a light, watery wash of golden brown. I paint over the entire deer, except for the white areas. I mix black, using thick ultramarine blue and burnt sienna. When the golden wash is dry, I paint the black on the eyes, nose, around the ears, and on the tip of the tail. This gives me a warm underpainting and establishes my darkest value, setting the stage for a great deer.

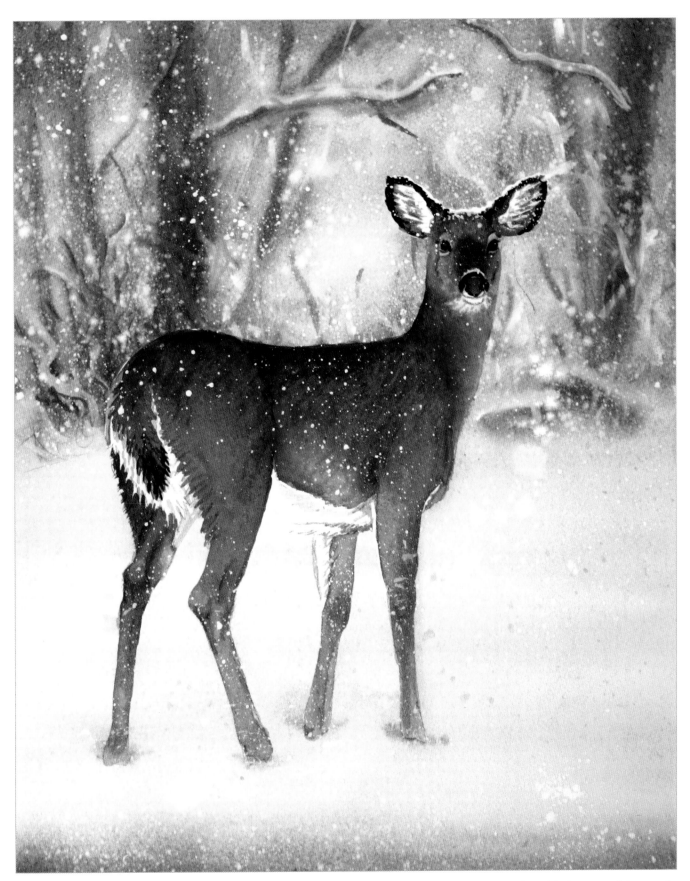

**6.** I mix more burnt sienna and ultramarine blue to paint the deer. Note that deer are darker along the bridge of their nose and the top of the neck and back. Most of the deer is a medium value, except for the lower legs and a small area around the eyes. I paint the gray-brown mix on the dark areas and add more water to this color as I paint the lighter areas. The more watery wash lets my golden underpainting show through. When the second wash is dry, I paint a few slightly darker shadows around the front and back leg muscle groups to give the deer shape. I put some light gray shadows in the white areas. I use a small brush and short strokes with my brown mix to suggest a little hair detail in a few spots, but I'm careful not to overdo it. Using white paint, I put a tiny highlight in each eye and dab some white snow on the deer's head and ears. Using my toothbrush, I spatter a little white snow over the deer and whole painting, being careful not to cover the deer's face.

# Kitten

Kittens are hard to resist—in real life or in paintings! By using a limited palette of only three colors for this entire painting, the gray kitten and pink quilt blend seamlessly into a unified image. By using light washes of color to set the tone, and darker washes for shadows and detail, this painting takes form quickly. The finishing touches add professional polish that should make any painter proud.

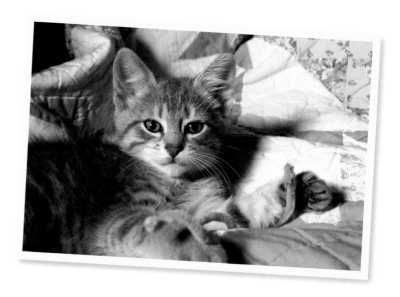

## Palette
aureolin yellow, cobalt blue, opaque white, permanent rose

**1.** I use graphite paper and a pencil to trace the outline of the kitten and quilt onto my watercolor paper. I pay special attention to the eyes and the length of the fur. The face has short fur, while the legs and body have long hairs. The kitten's eyes are the center of interest for this painting, so I draw very accurate detail there. Then, with an old brush, I mask out the whiskers and long hairs in the kitten's ears. I also mask the white area around the eyes and some of the long white hairs on the chest and leg. Masking complex shapes like whiskers will allow me to easily paint the shadows behind them.

**2.** For my first washes I mix up watery pools of rose, orange (rose + yellow), and gray (blue + a bit of the orange mix). I start on dry paper with my ¾" brush and wash the rose over the quilt area and the kitten's ears, adding orange in a few places for variety. I wash the light blue-gray over the top of the kitten's head, body, and the paw on the right. This light underpainting establishes the colors without the need for perfection or details. I let the washes dry completely.

**3.** I mix a thicker puddle of rose, using more paint for a more intense color, and wash over about two-thirds of the quilt and the kitten's ears. I also put rose on the nose and the kitten's toy. For the shadows and darks, I mix blue + rose to make purple, and then add a tiny bit of yellow to tone down the purple. I keep some of this mix very dark for the eyes. Then I add water and wash in the shadows behind the quilt and kitten, behind the masked hairs in the left ear, and over the back of the kitten. Adding the shadows and eyes makes the kitten seem to suddenly appear!

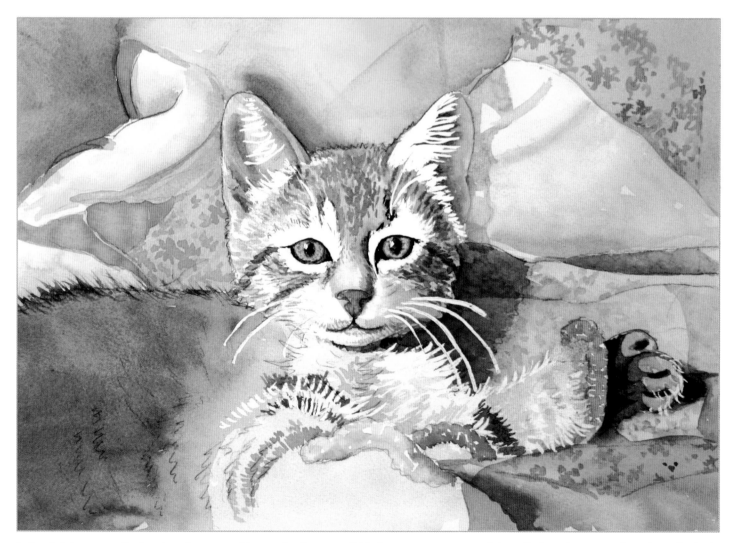

**4.** I switch to my smaller brush and use rose, blue, and yellow to scribble in a pattern on some of the quilt. I continue to work on the quilt shadows, using my dark mix from step 3 on dry paper and then softening the edges with clean water. With my gray mix from step 2 and my small brush, I put fur on the kitten's head with small, short strokes, letting some of the tinted paper show through. Once dry, I add another layer of darker strokes to create the subtle stripes in the kitten's fur. Working on dry paper with multiple layers gives me easy control over the values.

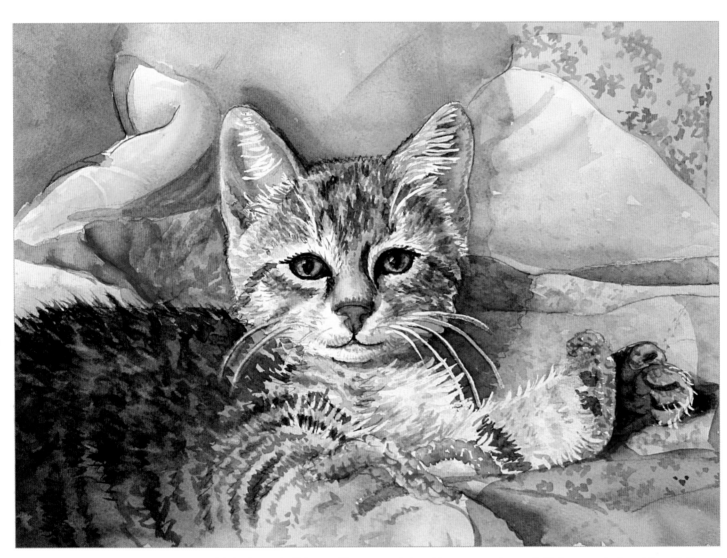

**5.** Now that the values of the face are established, I peel off the masking to reveal the white paper underneath. To incorporate the white with the other painted areas, I carefully add some tiny strokes to blend the white in. I also apply some subtle shadowing to the white chest and legs to suggest form and fur. On the kitten's back, I mix a large puddle of my dark mix (see step 3) to paint the darker stripes loosely over the initial blue-gray wash. The painting is almost finished, and I step back to evaluate for my final details.

**6.** Finishing touches are often quite subtle, but can add a lot to the final look. I add yellow to the left side of the quilt to balance the yellow on the right. Then I add white to the ear edges and darken the shadow behind them so they stand out. In the fold of quilt in the upper left corner, I continue the shadow past the edge for a smooth transition. I add a few white hairs in the dark areas of the kitten. The initial washes helped set the mood, shadow, and color for this piece. Building up the forms and adding the finishing details add refined polish, making this watercolor the perfect balance between realistic detail and glowing color.

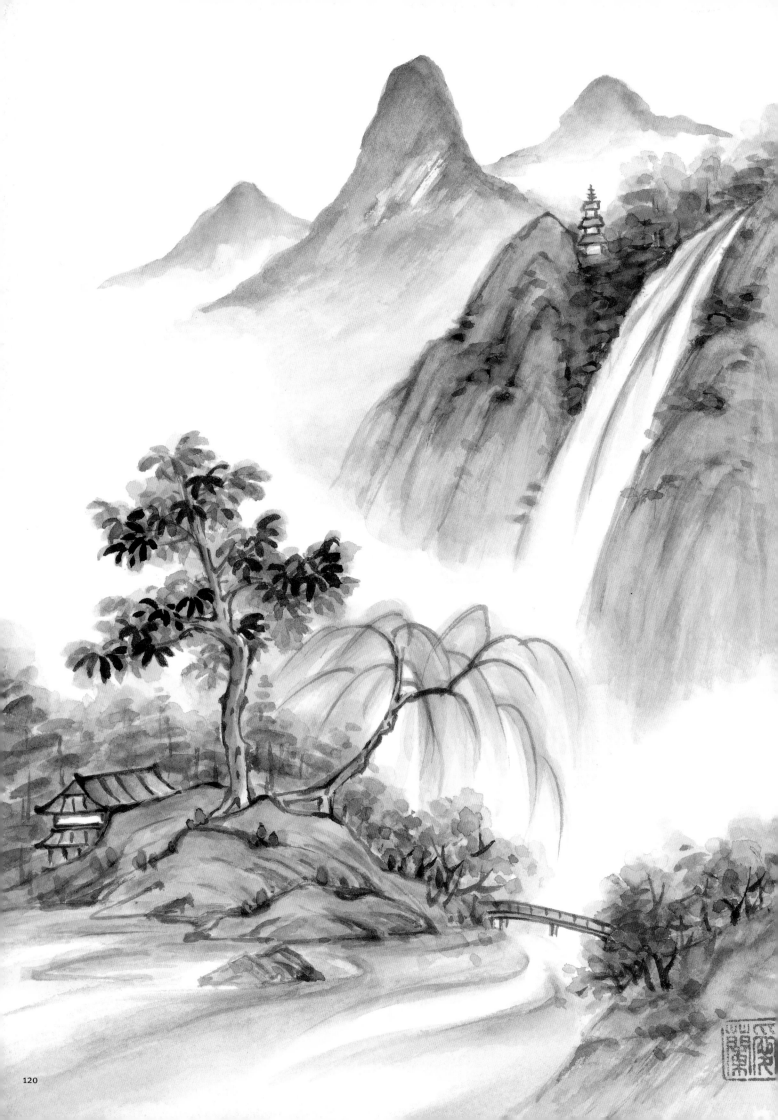

# CHAPTER 5

## Chinese Brush

### with Helen Tse

Chinese brush painting has been in existence for more than 2,000 years. During the Han Dynasty, which began in 200 B.C.E., the Chinese began using stiff-hair paintbrushes soaked in a mixture of pine soot and water to record events in their lives. Using sheets of silk, bamboo, and other types of wood as painting surfaces, the Chinese created images that were not necessarily accurate or realistic representations of a subject—instead each stroke simply suggested the spirit and character of the subject. Over the years, the materials and subject matter for Chinese brush has expanded—watercolor is an ideal medium for Chinese brush because it allows you to maintain the fluid nature of the art form. Follow along with the project in this chapter and soon you'll develop the skills you need to render your own beautiful collection of Chinese brush paintings!

# Tools & Materials

To paint in the style of Chinese brush, you need only "The Four Treasures" of an artist's studio: paper ("zhi"), a brush ("bi"), an ink stick ("mo"), and an ink stone ("yan"). But there are a number of additional materials that can enhance your experience—from a decorative brush rest to vibrant watercolor paints. Below you'll learn about all the materials needed to complete the Chinese brush projects in this chapter. Take some time to get to know your tools: The more comfortable you are with them, the more confident you will be while painting.

### Paints

Over time, Chinese brush materials have expanded from black ink alone to include colorful ink and paint. Watercolor is the ideal Chinese brush medium because it allows artists to maintain the fluid nature of the art form. For the projects in this chapter, you'll need seven colors: crimson, lemon yellow, sap green, magenta, Chinese white, burnt sienna, and ultramarine blue. Squeeze a color onto your palette and mix it with water to create a wash; the less water present in the mixture, the more intense the color will be.

### Water Spoon

A small spoon can be used to transfer water from a ceramic dish to your palette (see page 123). The spoon allows you to add smaller quantities of water than you would be able to achieve by pouring.

### Brush Rest

A brush rest is designed to protect brush bristles between uses. If you purchase a ceramic brush rest like this one, place the upper section of the handle (near the tip) on one of the indentations of the brush rest. Never let the bristles stand in water for any length of time, or they will become bent.

### Brushes

Although you can purchase Chinese brushes that are pre-assembled, you can also buy a few brush handles and separate brush tips (shown below). To assemble a brush, simply select the tip you wish to use and screw it on the end of a handle. Be sure to purchase a range of bristle sizes and textures, which will allow you to produce a variety of strokes. Chinese paintbrushes are distinct from regular watercolor brushes because their bristles taper to a finer point. Their efficient shape combines qualities of both round and rigger (or liner) brushes, as they can hold a large amount of ink and produce fine detail with their tips. There are two types of Chinese brushes available: stiff hair (also called "wolf hair") and soft hair (also called "goat hair"). Stiff-hair brushes are best for producing precise or coarse strokes, and soft-hair brushes are great for rendering delicate textures. The lessons in this book indicate what type of brush and which general sizes to use to complete each project; but before you begin, it's a good idea to become familiar with the way each size and type responds to your support.

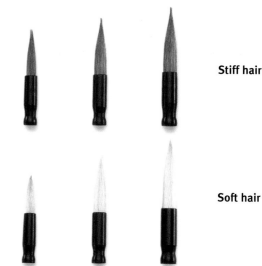

**Stiff hair**

**Soft hair**

## Ceramic Palette and Dish

Look for a ceramic palette that has multiple wells (pictured below left) so you can mix several washes at once. A ceramic dish (shown below right) with one large well is great for holding fresh water to add to your paints or ink stick. (You also may want to have an additional jar or bowl for rinsing your brushes between colors.)

## Paper

Although you can paint on a variety of surfaces, also called "supports," paper is used most often. Most Chinese brush artists choose to work on rice paper, which is an absorbent material that allows for soft edges and responds to quick strokes, encouraging spontaneity. However, rice paper is very thin and can easily be torn by heavy pencil stroking or erasing, so you'll want to sketch very lightly or use charcoal instead of a pencil. You also may want to try using cold-pressed watercolor paper, a sturdier support that can handle heavier pencil stroking and erasing.

## Ink Stick and Ink Stone

An ink stick is a pressed block of pigment that releases color when moistened. To create an ink wash, put about a teaspoon of fresh water in the well of the ink stone. Then quickly grind the ink stick in a circular motion for about three minutes until the water thickens and becomes black. Add more water to make a lighter ink wash. Before each use, make sure the stone is clear of any dry ink. Always use fresh water each time you paint, and always grind the same end of the stick.

*Holding the Brush*

To create the fresh and flowing lines of Chinese brush, it's imperative to hold the brush correctly. Sit up straight and place the paper on your table or work surface. (You may want to slip a piece of felt beneath your paper to keep it from sliding and to protect your table.) Then practice making strokes using the positions shown below. There are three basic positions: vertical with your four fingers on one side and the thumb opposite (A), vertical with two fingers on one side and the other two fingers and thumb opposite (B), or slanted with your wrist rotated and the brush held at an angle to the paper (C).

A
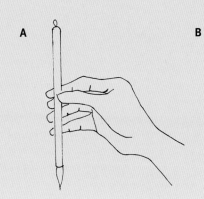

B

C

# Basic Techniques

Before you attempt to create a Chinese brush painting, it's important to know how to produce the various strokes that this art form comprises. These graceful movements are crucial for suggesting fluidity and spontaneity. Because the simplicity of this art form requires a minimal number of strokes, each one must be placed carefully and with purpose. Follow the instructions on these pages to master these essential skills.

## Practicing Strokes

Every stroke should be one fluid movement—press, stroke, and lift. Begin by loading a medium brush with an ink wash and experiment with the amount of pressure you place on the brush. You'll notice that you need only a light touch; pressing too hard releases a lot of ink or paint from the bristles and can cause unwanted pools of pigment. (If this occurs, you can dab up the pools with tissue or a paper towel.) However, using different amounts of pressure varies the thickness of your strokes, so you'll want to discipline your hand to achieve consistent results.

**Line Strokes**  Pull the brush across the paper in a straight line, pausing briefly at each end. This will cause the ends to be a bit heavier than the majority of the stroke.

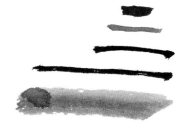

**Dot Strokes**  Hold the brush upright and press only the very tip against the paper. The less pressure you apply, the smaller the resulting dot will be.

**Long Dot Strokes**  Hold the brush at an angle to your paper and press down with the point. Vary the position of the brush to create dots in different directions.

**Press-and-Lift Strokes**  Press the brush to the paper, spreading out the bristles as you stroke. When you lift the brush, the bristles spring back, resulting in a thinner stroke.

**Side Strokes**  For wide strokes, hold the brush at an angle to the paper and paint with the body of the brush. Lift up at the end for a tapered finish.

**Blend-and-Tip Strokes**  Dip your brush in one color; then dip only the tip in another color (called "tipping"). The stroke will show a gradation of the colors.

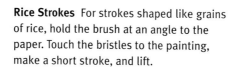

**Rice Strokes**  For strokes shaped like grains of rice, hold the brush at an angle to the paper. Touch the bristles to the painting, make a short stroke, and lift.

**Curve Strokes**  Holding the brush at an angle to the paper, press down the tip and make a small swoop with your brush as you stroke.

# Warming Up

Use the strokes you learned on the previous page to complete the following projects. Follow the steps with your eyes, trying to distinguish the various strokes that make up each step; then practice replicating the subjects.

**Bamboo**

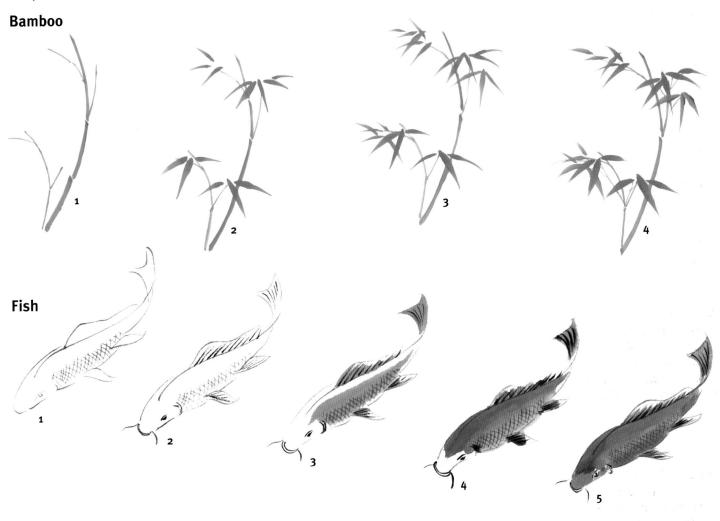

**Fish**

## Using Watercolor Paints

Watercolor paint needs to be thinned with water before use. The more water you add, the lighter the color will become, as shown below. To complete the projects in this chapter as demonstrated, you'll also have to mix paint colors. For example, you can produce a vibrant purple by mixing magenta and ultramarine blue washes. When the project calls for a color not provided in a tube, you will be told which colors to combine to create the desired color.

**Creating a Value Scale** Throughout this chapter, colors are sometimes described as "dark," "light," or "medium." When a project calls for a "dark" (or "strong") color, use very little water; for a "light" color, add a lot of water so the color is very light; and for a "medium" color, add enough water to achieve a color somewhere between dark and light. Making value scales like the one above will help you get to know the proportion of water to paint needed to create the desired value.

# Sunflower & Ladybug

Bring out the playful essence of a sunflower by focusing on the irregular shapes and the movement of the petals. Vary your strokes to create the petals, sweeping out from the center to suggest a pinwheel movement. To add more interest, stroke thin expressive lines on the petals and leaves to accent the subject's curves.

**1.** Use a pencil to lightly outline the flowers and ladybug on your choice of paper. Your initial sketch acts as a guide for placing the strokes of each successive step.

**2.** Mix equal parts of sap green and crimson, but refrain from blending to achieve a mottled color. Use a large stiff-hair brush to apply this color in the flower's center. Next saturate a large soft-hair brush with a yellow wash; then tip the brush with burnt sienna, and paint the petals using side strokes.

**3.** Before adding each new petal around the center, rinse, blot, and reload the brush. Vary the petal shapes by using slightly different stroke curves, lengths, and widths. Load a large stiff-hair brush with a mix of ultramarine blue, sap green, and ink; then paint the leaves with broad side strokes. The subtle gradations within the strokes give the leaves dimension.

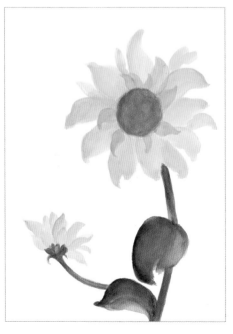

**4.** Using a medium soft-hair brush loaded with a mix of yellow and burnt sienna, add the petals of the small flower. Then darken the mix with more burnt sienna to add smaller petals on the larger flower. Add sepals to the small flower, and paint the thick stems with a large stiff-hair brush loaded with sap green and tipped with crimson.

## Ladybug Detail

First paint the oval shape of the ladybug's body with a thick wash of crimson and a small stiff-hair brush (A). Next create a dark ink wash, dot on the head, and stroke a small line down the back to separate the wings (B). Now add two small dots on each side of the back. Complete the ladybug by adding thin legs and antennae (C).

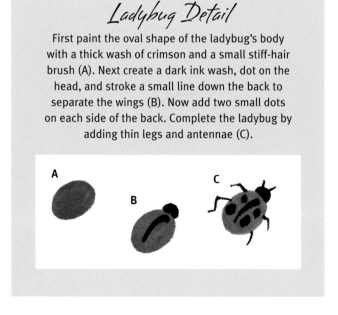

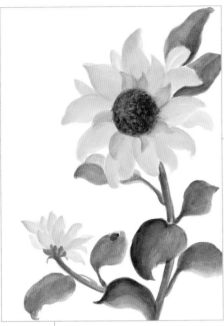

**5.** Using a small stiff-hair brush, dot a mix of crimson and ink on the flower's center in a crescent formation; apply dots of yellow wash in the upper left for dimension. Create a wash of sap green, ultramarine blue, and ink, and use a large stiff-hair brush to complete the rest of the leaves with side strokes. Follow the steps on page 126 for the ladybug.

**6.** Use a small stiff-hair brush dipped in a mix of burnt sienna and light ink to apply free-flowing, partial outlines to the flower petals. Use another small stiff-hair brush to add leaf veins with line strokes and varying values of ink. As you add the veins, curve your lines to follow the leaf forms. When the paint is completely dry, erase any visible pencil lines.

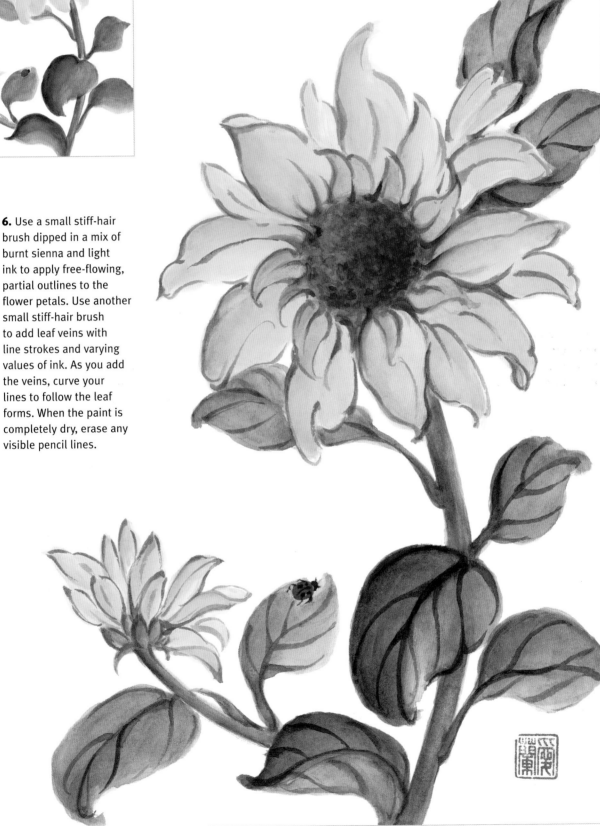

# Mountains & Clouds

Capture the misty, dreamlike quality of this mountain scene by creating the illusion of depth. Apply various intensities of washes over one another, using the sharpest edges and most intense colors for the house and trees on the right, as these are closest to the viewer. This will push the background elements farther into the distance.

**1.** Create an outline of the painting in light pencil. Following your sketched lines, apply quick line strokes with a small stiff-hair brush and medium ink to define the mountains and the house. Saturate a medium soft-hair brush with a mixture of burnt sienna and lemon yellow to wash over the mountains. For the mountain on the far left, apply a more intense wash.

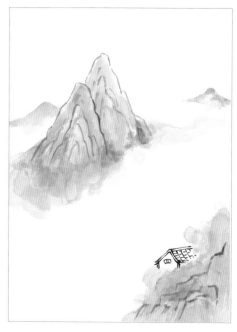

**2.** Complete the detailed outline of the house. Now create a blue-gray mix of ultramarine blue, white, and a bit of ink. Use a medium soft-hair brush to paint the distant mountain on the right. Then stroke this wash over areas of the mountains, allowing some areas of pure burnt sienna to show through. Create several intensities of the wash, allowing each to dry before applying the next.

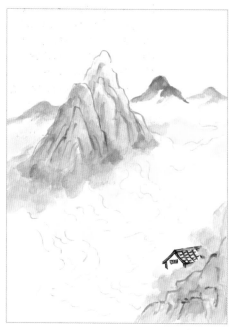

**3.** Now dilute the blue-gray mix from step 3 with a bit of water and use a small soft-hair brush to add thin, squiggly lines to suggest clouds. Add more ink to this mix to paint a darker, distant mountain. Then mix burnt sienna with a bit of crimson to create the roof color. Use the tip of a very small stiff-hair brush to apply this mix with short, precise strokes.

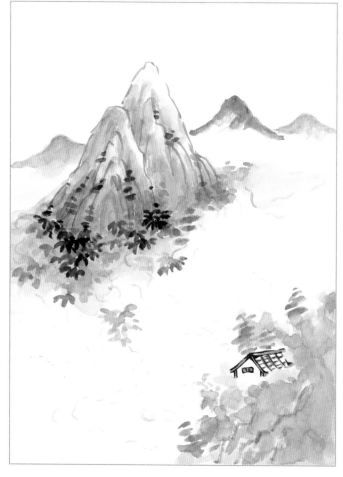

**4.** Add the trees in several layers with long dot strokes, using stronger washes for the nearest trees. This dappled pattern provides a pleasing contrast to the soft washes of the mountains. Now begin adding the trees around the house.

## Tree Detail

Create a light wash of ultramarine blue, white, and ink. Using a small soft-hair brush, suggest the farthest trees using wide, parallel rice strokes (A). Then strengthen the wash and repeat the process, now overlapping the fainter trees (B). Add a few more tree groups, varying the proportions of blue and ink for each tree. Finally add vertical line strokes for tree trunks (C).

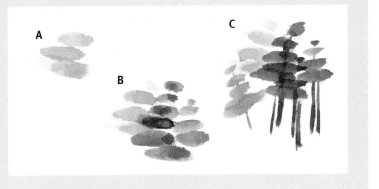

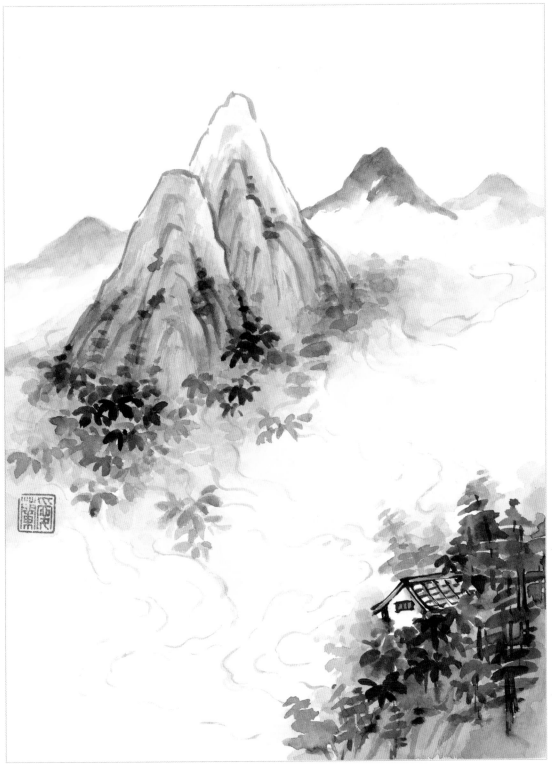

**5.** Complete the trees in the foreground, working around the house and finishing with your boldest strokes. (See "Tree Detail" above.) Then unify the blues of the painting by adding a very light blue wash over the clouds with a medium soft-hair brush. Make any further adjustments to your painting, and then admire your finished work!

# Enhancing a Painting

Many Chinese brush paintings lack backgrounds, which can detract from the simplicity of the intended focus. Instead the subjects often are set against the white of the paper, providing artists with the freedom to alter the shapes and frames of their paintings. For this horizontal image of a bird and flower branch, take advantage of this freedom by developing a painting in the shape of a traditional Chinese fan.

**1.** Sketch the fan shape with a pencil, followed by the elements of the painting. You may want to use a ruler and a compass to perfect your lines. Remember that you can use an eraser to remove any lines that still show after your finished painting is completely dry.

**2.** Each flower consists of five converging petals, which are wider at the top. Saturate a medium soft-hair brush with thin white, and then tip it with magenta. Following the outlined shapes, apply side strokes to paint the flowers and buds.

**3.** Saturate a small stiff-hair brush with magenta and use line strokes to make the flower veins. Add line strokes for green sepals and stems with a small stiff-hair brush. Mix sap green, ultramarine blue, and ink to create the leaf colors; then apply the color, making broad strokes with a large soft-hair brush.

**4.** Using long line strokes and a small stiff-hair brush, add six yellow stamens to each flower. Add anthers at the top of each stamen using rice strokes with a strong mixture of burnt sienna and ink. Then load a small stiff-hair brush with ink to paint the veins of the leaves with thin line strokes.

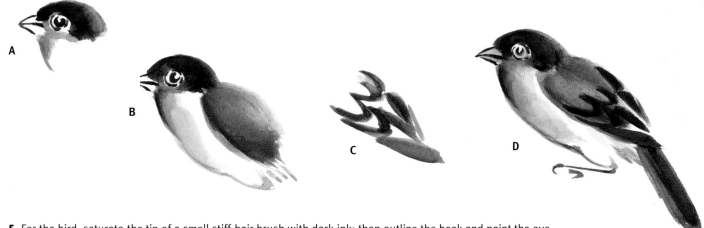

**5.** For the bird, saturate the tip of a small stiff-hair brush with dark ink; then outline the beak and paint the eye, leaving a white highlight. Apply curved side strokes for the top of the head; then dilute the mix to paint the throat (A). Mix ultramarine blue and light ink and use a small soft-hair brush to apply side strokes over the bird's back; then add more water to the mix and apply it over the throat and abdomen (B). With a mix of ultramarine blue and dark ink, paint feathers in V shapes (C). Use the same mix to paint the tail with downward strokes. Apply line strokes to the foot and claws using medium ink. Add a bit of lemon yellow to the iris, abdomen, and feathers near the tail. Add light crimson to the beak (D).

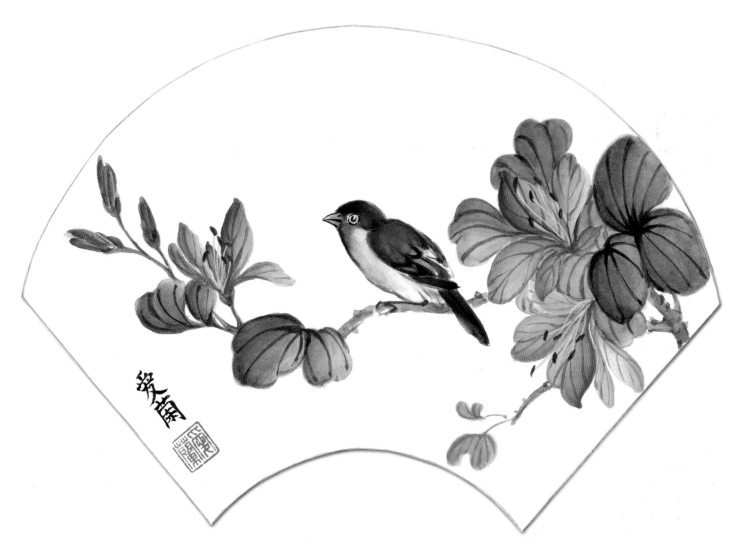

**6.** Now connect the flowers and leaves with branches. Mix burnt sienna with light ink, load a large stiff-hair brush, and paint the branches with line strokes. Using a small soft-hair brush, create texture by adding knots to the branches with an ultramarine blue wash. Add the bright leaves at the bottom with sap green. Now darken the shape of the fan with your pencil.

# Goldfish

Chinese brush painting embraces simple but dynamic "compositions," or arrangements of elements within paintings. For this aquatic scene, break up the round shapes of the fish and ripples of water with a diagonal branch. This branch not only helps guide the viewer's eye through the painting, but its green and brown colors also provide an exciting contrast to the reds and oranges of the goldfish.

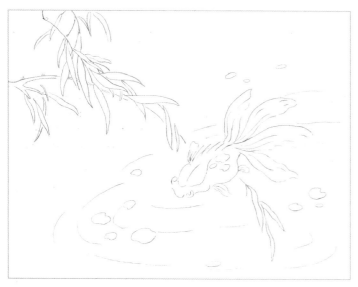

**1.** Following the sample, lightly sketch the elements of the painting in pencil. Be sure to include the shapes of the lily pads, as well as the swirled lines in the water.

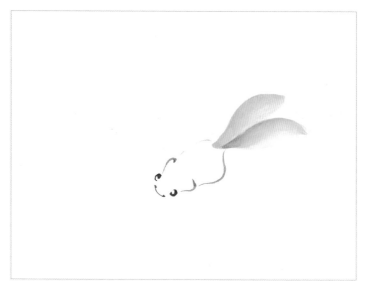

**2.** With a small stiff-hair brush dipped in medium ink, outline the mouth, eyes, and body of the fish. Use a large soft-hair brush to paint the center tail fins with side strokes and a mix of crimson and yellow.

**3.** Follow the process described in step 2 to complete the tail. Then use a small soft-hair brush to add pectoral fins with a more diluted orange.

**4.** Use a medium soft-hair brush with a light blue mix of white and ultramarine blue to wash over the body and mouth. After the paint has dried, rinse the brush and load it with a dark orange mix of crimson and a bit of yellow; then paint the head and body spots using irregular side strokes.

**5.** Using the same dark orange mix from step 4, add line strokes to the pectoral and tail fins. With a small stiff-hair brush and dark ink, add curving strokes along the top of the head and at the base of the tail. Then mix ultramarine blue and white to add curved strokes for water ripples.

**6.** With a medium soft-hair brush, apply press-and-lift strokes to paint the leaves in various shades of green. Use line strokes and a small stiff-hair brush to add branches with a mix of burnt sienna and ink. Wash over the water with a large soft-hair brush and light sap green.

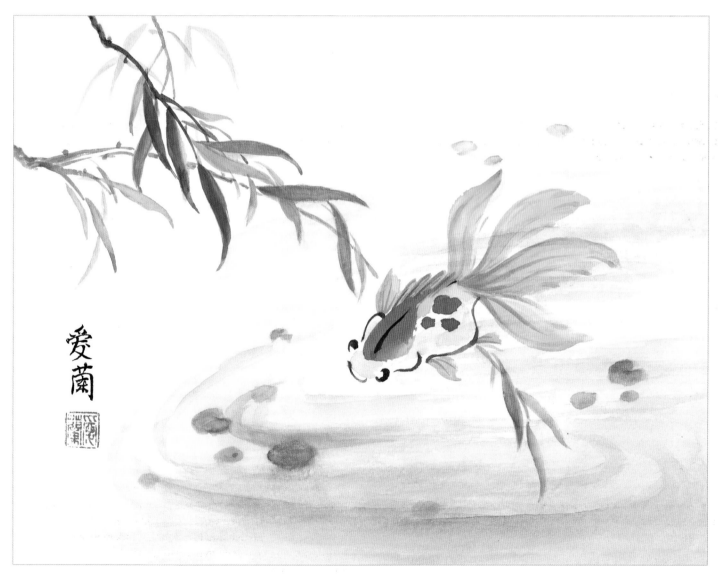

**7.** Using the same approach as in step 6, complete the left branch and the rest of the willow leaves. Create a mixture of sap green, ultramarine blue, and burnt sienna to paint the lily pads using curve strokes and a large stiff-hair brush. Stand back from your painting and squint your eyes to better see the values. Adjust the painting as necessary.

# Lotus & Dragonfly

Engage the viewer by incorporating contrasting textures in your painting. In this lotus flower scene, the soft, pink petals and smooth leaves are offset by the spiky texture of the stems. The thin, curving blades of grass in the background provide an even greater amount of contrast and drama.

◀ **1.** Use a pencil to gently sketch a complete outline. Use curved, tapered strokes to create the flower petals.

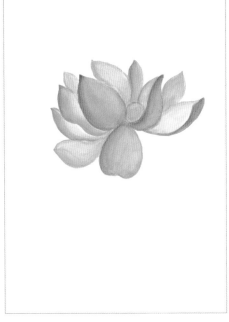

**2.** Soak a large soft-hair brush in thinned white and tip it with crimson; then follow the contour of the petals with side strokes. Paint the center petal first, moving outward to other petals with a fainter wash. Add the lotus seed pod using a small stiff-hair brush and sap green.

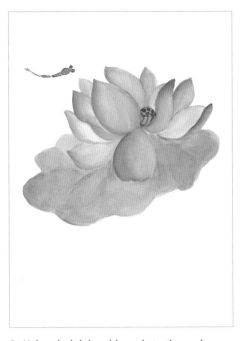

**3.** Using dark ink, add seeds to the pod. Saturate a large stiff-hair brush with a wash of light burnt sienna mixed with sap green; then stroke, following the curves of the large leaf. To paint the dragonfly's body mix crimson and burnt sienna and apply the color with a small stiff-hair brush.

**4.** Use a small stiff-hair brush loaded with a mix of crimson and yellow to paint the short curve strokes of the stamen. Using a large stiff-hair brush, darken the shadowed areas of the large leaf with a mix of ultramarine blue, ink, and sap green. Add the lower leaf, pulling down the color with two side strokes. Then use a thin wash of burnt sienna and a medium soft-hair brush to add the dragonfly's wings.

◀ **5.** Outline the flower petals using the tip of a small stiff-hair brush and strong crimson; then dilute this wash to paint the delicate lines of the petals. Mix ultramarine blue with light ink and paint the leaf veins with a small stiff-hair brush. Add thin, light lines to the dragonfly's wings using burnt sienna mixed with a bit of crimson, applying light ink for legs. Add the stems using thick line strokes and a large stiff-hair brush loaded with a mix of sap green, ultramarine blue, and burnt sienna.

**6.** Randomly place dots on the stems using a small stiff-hair brush and medium ink, giving the stems some texture. Use a small stiff-hair brush loaded with burnt sienna and light ink to add the brown grass behind the flower. Create the blades using long, light line strokes that taper to a fine point.

# Peach Blossoms & Fisherman

Artists often use color "temperature" to communicate the mood of a scene. Color temperature refers to the "cool" feel of blues, greens, and purples, and the "warm" sense of yellows, oranges, and reds. In this peaceful lake scene, focus on conveying the warmth of the atmosphere through your use of color. Use bright pinks and oranges to create a sunset sky, and dot the land with red for peach tree blossoms.

**1.** Following the example above, lightly sketch every element of the scene with pencil, adding a few curving lines to indicate movement in the water.

**2.** Load a small stiff-hair brush with light ink and use line strokes to outline the land masses, houses, and mountains. Wash over the land and mountains with a medium soft-hair brush and light burnt sienna.

**3.** With a medium soft-hair brush, layer side strokes of light green over areas of land and water. Mix green and light ink for distant mountains; use a crimson and magenta mix and a small stiff-hair brush for the blossoms.

## Fisherman Detail

Use a small stiff-hair brush with medium ink to outline the hat (A). Now outline the face, body, and arm using the very tip of the brush (B). Next stroke in the top of the boat; then add the boat's bottom and suggest the far rim (C). Add the fishing line with a long, light stroke that seems to disappear into the water. Then accent the shirt with blue and color the boat and the hat with burnt sienna (D).

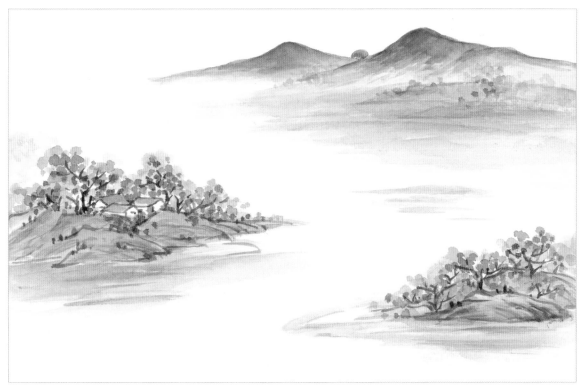

**4.** Apply a wash of ultramarine blue and white over the roofs and areas of water near the land; then apply light ink mixed with ultramarine blue to the second distant mountain using a large stiff-hair brush and side strokes. Paint the sun with dark crimson and add another layer of blossoms. Mix ink and burnt sienna and apply thin line strokes for branches.

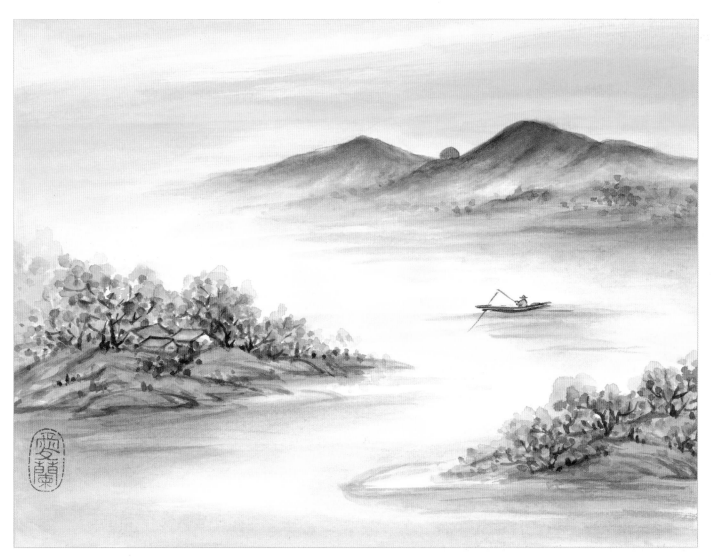

**5.** Add the fisherman and the boat (see the detail on the opposite page); then paint the sky using a large soft-hair brush loaded with various values of crimson and lemon yellow, applying the colors separately with broad, horizontal side strokes. Allow the colors to blend on the paper.

# Pavilion Landscape

As you approach this detailed scene, keep in mind that Chinese brush embraces simplicity. Outline every element using varying values of ink; then build up color with layers of wash, allowing the paint to dry between applications. Breaking down a painting in this manner not only simplifies the process, it also prevents your mixes from becoming muddy, instead allowing washes to visually blend, producing rich colors.

**1.** Following the guide above, lightly sketch an outline of the composition in pencil.

**2.** Use a small stiff-hair brush and medium ink to outline the land mass and tree trunks. Apply strokes to indicate the bumps and curvature of the land's surface. Create the tree trunks with a series of short, choppy line strokes to suggest the bark's rough texture.

**3.** Use the same approach as in step 2 to complete the land mass at right; then connect the masses with a bridge using a small stiff-hair brush and medium ink. Use this same brush and a medium ink wash to indicate the pavilion.

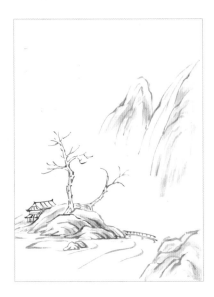

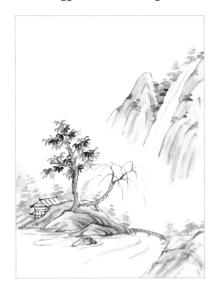

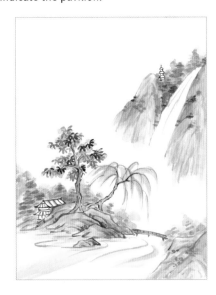

**4.** Load a small soft-hair brush with medium ink to create the softer lines of the mountains. Then use a medium soft-hair brush to apply a light ink wash over the rooftop, tree trunks, bridge, and the crevices in the rocks and mountain. Suggest the flow of water with curve strokes using a small soft-hair brush and light ink.

**5.** For the branches of the willow tree, use a small soft-hair brush dipped in light ink to apply curving line strokes that taper at the tips. Paint the leaves on the tree and indicate shrubbery throughout (see details on the opposite page). Saturate a medium soft-hair brush with burnt sienna to color the tree trunks and the bridge. Then apply a lighter burnt sienna wash over the land and mountain areas.

**6.** Using a medium soft-hair brush, apply a layer of green wash over the trees, mountain, foliage, and water. Paint the willow tree branches with curving strokes; then add more background trees with different values of green. Outline the distant pagoda with medium ink and the tip of a small stiff-hair brush.

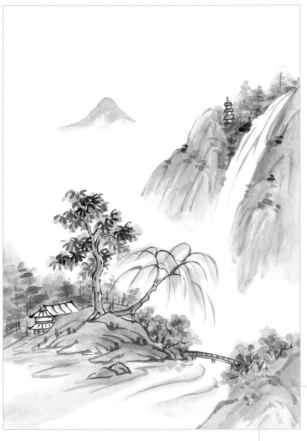

**7.** Accent the pagoda on the hill and the pavilion with medium crimson. Dot on the red blossoms with a small soft-hair brush, using different values of crimson. Add some branches with a small stiff-hair brush using burnt sienna mixed with ink. Finally use a medium soft-hair brush and diluted crimson to paint the background mountain.

## Leaf Cluster Detail

To create clusters of leaves, first apply short, thick side strokes with dark ink and a small soft-hair brush (A). Paint four or five leaves to make a second cluster (B). Then add more clusters using varying values of ink; this will push the lighter clusters into the distance, creating a sense of depth (C).

## Tree and Foliage Detail

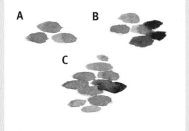

To suggest trees and foliage, start by using a medium soft-hair brush to create a cluster of light ink brush strokes (A). Then add more strokes, using medium ink to deepen the value (B). Continue adding varying values of light and medium ink, applying parallel rice strokes in a triangular formation (C).

**8.** Load a medium soft-hair brush with a wash of ultramarine blue and ink to paint the middle and right sides of the distant mountains using side strokes. Then use a small soft-hair brush to apply a mixture of ultramarine blue and thin white to the leaves, background foliage, land, mountains, and water. Add more intense strokes of green to the trees for your final touches.

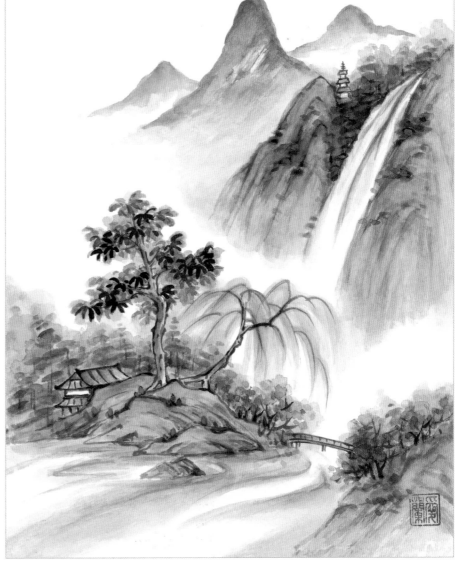

# About the Artists

**THOMAS NEEDHAM** was raised in Redondo Beach, California, where his love of art and athletics shaped his sense of form and motion. He is a graduate of California's renowned Art Center College of Design with a double major in advertising and illustration. He has received numerous awards for his oil, acrylic, and watercolor paintings. Thomas currently resides in Appling, Georgia, where he paints and teaches painting classes at the Gertrude Herbert Institute of Art in Augusta. Visit www.thomasneedham.com to learn more.

**RONALD PRATT** is an associate member of the National Watercolor Society, California Watercolor Association, and a member of several San Francisco Bay Area art groups. His award-winning paintings are proudly displayed in homes and galleries around the world. Ronald's work expresses the amazing beauty and fascination of life. His subject matter varies from dynamic seascapes to peaceful landscapes, from still lifes to surreal abstracts, and from florals to the human figure. View more of Ronald's work at www.ronaldpratt.com.

**HELEN TSE** studied under several renowned Chinese watercolor masters and won her first award at age 12. Following a basic education in Canada, she moved to Orange County, California, where she has renewed her childhood passion for Chinese watercolor. She has won numerous awards at juried shows and competitions and is now devoted full time to painting, exhibitions, and teaching. Her unique work, which blends traditional form with western touches, has been represented in many private collections, local museums, galleries, and national shows.

**DEB WATSON** is a an award-winning, self-taught artist who spent a good portion of her adult life as an operating room nurse. Working long hours and raising a family didn't leave much spare time, but she continued to paint whenever she could. Deb quit nursing in 1999 to become a full-time watercolorist. She finds inspiration for her art in unlikely places, such as dirty gutters, messy restaurant tables, and other subjects that often go unnoticed. Deb maintains a busy teaching schedule and loves helping her students rediscover their own passion for art, as she did. Her classes are all about loosening up and having fun. To learn more about Deb visit www.debiwatson.com.

**NANCY WYLIE** has won numerous awards as a realist painter working in watercolor, pastels, and oils. As a 6th generation native of Colorado, she loves how the blue skies and sunshine give her inspiration for her work, which is filled with depth and light. She graduated from the University of Northern Colorado, taught art in Jefferson County Public Schools, and now paints full time, teaching workshops, giving critiques, and jurying shows locally and nationally. Visit www.nwylie.com to learn more.

# Index